PCPhoto

Digital SLR
HANDBOOK

ROB SHEPPARD

LARK BOOKS
A Division of Sterling Publishing Co., Inc.
New York

Book and Cover Design: Sandy Knight
Layout: Michael Robertson
Photography by Rob Sheppard unless otherwise specified
Editorial Assistance: Haley Pritchard

Library of Congress Cataloging-in-Publication Data

Sheppard, Rob.
 PCPhoto digital SRL handbook / by Rob Sheppard.– 1st ed.
 p. cm.
 Includes index.
 ISBN 1-57990-602-8 (pbk.)
 1. Single-lens reflex cameras–Handbooks, manuals, etc. 2.
Photography–Digital techniques–Handbooks, manuals, etc. I. Title.
TR261.S52 2004
775–dc22

 2004001509

10 9 8 7 6 5 4 3 2 1
First Edition

Published by Lark Books, a division of
Sterling Publishing Co., Inc. New York.
387 Park Avenue South, New York, N.Y. 10016

Distributed in Canada by Sterling Publishing,
c/o Canadian Manda Group, One Atlantic Ave., Suite 105
Toronto, Ontario, Canada M6K 3E7

Distributed in the U.K. by Guild of Master Craftsman Publications Ltd., Castle Place,
166 High Street, Lewes, East Sussex, England BN7 1XU
Tel: (+ 44) 1273 477374, Fax: (+ 44) 1273 478606
Email: pubs@thegmcgroup.com, Web: www.gmcpublications.com

Distributed in Australia by Capricorn Link (Australia) Pty Ltd.,
P.O. Box 704, Windsor, NSW 2756 Australia

PC Photo is a registered trademark of Werner Publishing Corporation.

If you have questions or comments about this book, please contact:
Lark Books, 67 Broadway, Asheville, NC 28801, (828) 253-0467

contents

introduction

For many, many years, the 35mm single lens reflex (SLR) was the camera of choice for anyone who wanted to get the most out of their photography. Sure, you could get excellent images from other types of cameras, but only the 35mm SLR provided the right combination of size, film selection, lens preference, price choice, and total system flexibility. There were cameras and accessories that could meet any photographer's needs, from the proud new parent to the professional photojournalist.

Yet by the 1990s, the 35mm SLR had hit its peak. New cameras offered more convenience and special features, but didn't really change the photography experience. Older 35mm cameras still worked fine for many photographers, particularly amateurs.

Digital cameras dramatically changed everything in the camera marketplace. At first, digital SLRs cost many thousands of dollars and offered only limited megapixels, so they did not influence most photographers. When advanced compact digital cameras came down under $1000, many photographers discovered that going digital offered some amazing posibilities, not the least of which was the review capabilities of the LCD monitor. You could see exactly what you got. It was even better than the old Polaroid cameras! And they offered much more: no limitations on the number of "shots per roll," photos that could be edited as you went, easy checking of exposure, quick review of flash exposure and angle, the ability to control and produce your own prints, and much more as we'll explore in this book.

Before I get too deeply into digital SLRs, you should know a little about me. I've been photographing since I was about nine years old and even built a darkroom when I was 13. I have worked professionally as a photographer, but I've never lost my "amateur's" love of the medium. That's probably one reason why I have enjoyed working as editor of *Outdoor Photographer* and *PCPhoto* magazines.

Over the years, I haven't always had the money for all the gear I really wanted. So, I carefully examined all the equipment that was available— looking at everything from technical data to how the gear handled. I quickly learned that the choice of cameras and accessories is a very personal decision. What works for one person may not be the best for another. I can guarantee that if a camera is picked purely for the "best" specifications and that owner doesn't like how it feels, those great specifications are worthless. The camera won't be used.

Lower prices for today's digital SLRs have made them a great buy and they are not badly made, either. They are full-featured, superb picture-taking machines. More expensive cameras do offer additional features, including better weather-proofing and more durable fittings, but every digital SLR on the market today has excellent photographic potential.

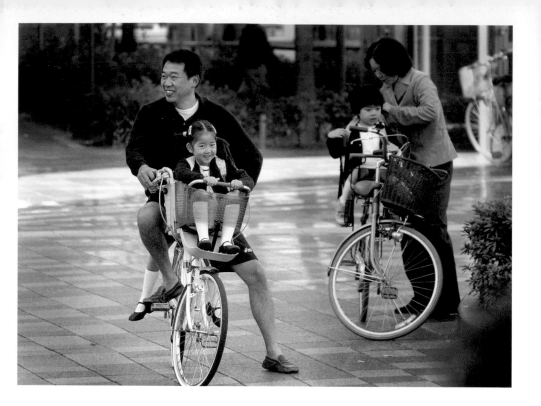

This book will help you get the most from your digital SLR. It includes tips for beginners and advice for advanced users. If you haven't purchased a digital camera yet, this book will help you to make that purchase wisely. No matter what your level, I hope this guide will help you enjoy using your digital SLR and take full advantage of its many possibilities. Don't be intimidated by the technology or the range of detail in this book. Just about any feature that was available with a traditional film camera can be found on a digital camera—and more! You may not choose to use all those features, but once you have read this book you should be able to smartly choose and use the controls that will work best for you. With your digital SLR, you truly join a revolution. Photography isn't changing, but the way you photograph is. The digital SLR is an invitation for everyone to find a new excitement and enthusiasm for photography.

the new SLR

Digital photography is not just different than film photography; in some ways it is better. Digital cameras differ from film cameras in a number of important ways. However, they don't so much change photography as they add new capabilities that really enhance the experience. In this chapter, we will explore the differences and similarities and give a quick overview of the technical features of digital SLR cameras.

• Digital SLR Benefits

There are still a few film photographers who do not believe digital capture is any good, but these are largely photographers who have never tried it. There is no question that film still offers a few benefits over digital, but the advantages of digital for most photographers far outweigh them.

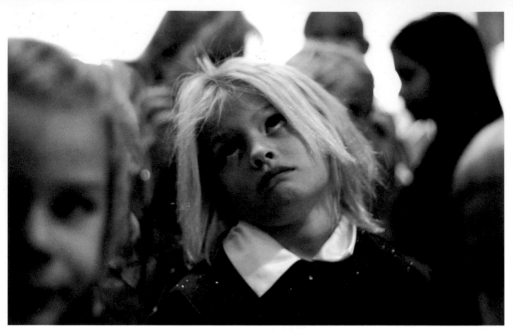

Digital SLRs give you a connection to the subject not possible with film. You can check and see that you got the shot at any time.

The Digital Advantage

- No cost pictures

- Shoot in any condition

- High ISOs with less noise

- More freedom to shoot

- Instant feedback

- More connection to the subject

- Joy of photography

No Cost Pictures

Once you buy the camera and a decent-sized memory card, you can shoot all you want with no additional costs. This has a big influence on photographers. After I bought my first digital SLR, my teenage daughter complained that I was always taking pictures. Why not? I didn't have to worry about film and processing costs, so I photographed everything. If my daughter and wife looked interesting—perhaps waiting to be seated at a local restaurant—I took their pictures. If my kids were acting in a play, I brought my camera. If I liked the photos, great. If not, they were gone in an instant. Taking more photos in all sorts of situations has helped me become a better photographer.

Shoot in Any Condition

With film there were definite limitations to casual photography. Different colors of light (indoors to outdoors) meant color problems, unless I was willing to use filters or flash. I didn't always have the right filter handy, and flash often didn't look natural. So, like most photographers, I limited my shooting to conditions that would give me a higher per-

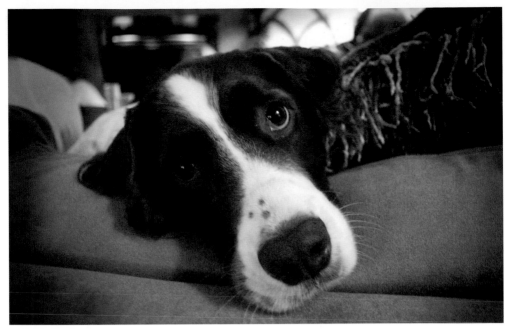

With a digital camera, you can set the ISO to match the conditions so flash is not necessary—a big benefit when photographing pets.

centage of likable photos. Also, if I was taking pictures outside, and then went inside, the light levels would change and I often needed a different film speed. With digital technology, I can quickly adjust the white balance of my camera to deal with different colors of light, and change my ISO on the fly or even from shot to shot.

High ISOs with Less Noise

As film speed goes up, so does grain. This is also true to a degree with digital cameras, but it is usually called noise. Today's digital SLRs offer higher ISO shooting speeds with much less noise/grain than might be expected based on film experience. By comparison, compact digital cameras with smaller sensors have more noise problems, which results in more limited ISO options. The larger pixels of digital SLR sensors grab more light and generate less noise, so that speeds of 800 through 600 are available on these cameras. The obvious advantage to

this is the ability to get better photographs in low-light conditions. But there is another distinct benefit: the chance to use slower zoom lenses in varied light conditions, like wildlife at dusk or portraits indoors.

More Freedom to Shoot

Combine the previous three benefits and we gain the freedom to photograph subjects in places we never would have considered before. Plus, since you can always erase photos as you shoot, you are free to photograph anything you like and experiment wildly with everything from composition to exposure.

Instant Feedback

Photographers have never before been able to photograph something and then instantly see that photograph. This is a huge benefit! (Even Polaroid film had a development

time). Instant feedback means you can con-firm that any setting—from f/stop to white-balance—is correct. You can experiment and see what a new setting looks like right away so you can decide if it will work for the subject or not. This means no longer having to accept compositions that aren't quite right because you can change your photo while still at the location. It also means you can catch problems quickly—like a bad expression on your subject—and correct them on the spot. You can now try flash in ways you never dared before, because you are finally able to see the results right away. Take the picture and check the LCD review—you'll immediately see what your flash did, in exposure and direction, and correct it as needed.

Digital cameras are such a pleasure to use that it is a joy capturing those important moments at school concerts.

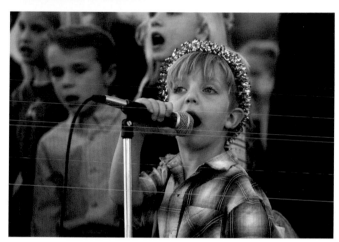

More Connection to the Subject

The instant feedback of the LCD gives a connection to the subject that photographers have rarely had before. Only those who shot Polaroids could come close. Now, photographers can see what their image looks like immediately as it is captured, then reshoot if necessary. You have the potential of seeing what the subject is really like in a photograph while still in the subject's presence. Because you can review your images right after taking them, you can see if the picture really captures what you think and feel about the subject while you have the opportunity to photograph the subject again.

Joy of Photography

Again and again, I have heard from long-time photographers that digital has revitalized their interest in picture taking. The reasons are pretty simple: less cost, more freedom, better and more consistent results, and the ability to interact photographically with the subject. The combination of more possibilities for success with the ability to experiment at no cost (including getting rid of the bad stuff instantly) usually leads to photography that is just more fun!

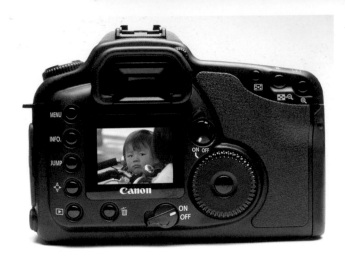

The immediate picture review provided by the camera's LCD is an invaluable feature.

• Digital Cameras Make Better Photographers

"Buy the new Acme Digital X camera and you'll make pictures like the pros." Probably not. Buying a new camera isn't going to suddenly make you a better photographer, and shooting like a pro takes a bit of work and experience.

But I do believe that using a digital camera will make most people better photographers—and that is no hype. I have seen this happen to me and to everyone I know who starts shooting a lot of photos with a digital camera. This is because a digital camera offers two things that will upgrade the quality of your photography. These are: the LCD monitor, which gives you instant picture review, and the memory card, which frees you from the cost limitations of film.

Instant Picture Review

Located on the back of digital SLRs is the LCD monitor, an instant giveaway that you are looking at a digital camera. Far more than that, it is a tremendous tool that you'll see emphasized again and again in this

book. Some manufacturers are realizing just how important it is, so they're making the screens bigger and easier to see.

Basically, the LCD monitor gives you an instant "Polaroid". That may sound redundant, but the LCD monitor truly is instant, whereas the Polaroid photo takes some time to process. You'll find a whole set of tips later in this book that will help you get the most from your LCD. For now, realize this—you can see your photo immediately and check on the spot to see if you got what you wanted.

Instant Proofing Ability

To understand the full implication of the LCD monitor, think about film. Remember picking up the processed film—of proms, kids' sports, and exotic vacations—and being disappointed? You wished you had gotten a better exposure, a different angle, taken more photos, or noticed the telephone pole behind your subject's head. Sure, you did your best to capture that precious moment. You used flash/didn't use flash, held steady/shook, took the cap off/forgot, and so on. You never knew for sure if you had captured the image you wanted until the film was processed later.

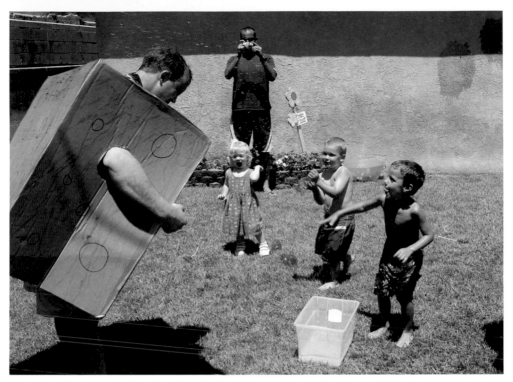

The snapshot of a kids' party is easy, but the **LCD** review will encourage you to go beyond it to a more interesting moment of candid composition.

Don't think that's just an amateur's concern. Pros would often shoot lots of film—varying exposure and composition—to be sure they got what they needed. Advertising photographers always shot Polaroids before shooting film to be sure the light, exposure and composition were just so. Yet, if they were photographing people, even they could never be totally sure everything was perfect because the Polaroid was only a test and not the real shot.

Thankfully, the digital camera changes all of this. Now, a quick look at the LCD review and you know immediately if your subject's eyes are open or closed. Closed? Just take the picture again. You can check to see if the group portrait shows everyone. You can see if you had the right angle, the perfect instant, if flash was good or bad, and so on.

As my photographer friend Jim Brandenburg says, this makes photography more organic. You can take the picture, then compare the image with the subject while you are still there. You can make any adjustments needed and retake the photo immediately. That is a wonderful benefit, regardless if you are a National Geographic pro like Jim or a parent photographing the kids playing soccer.

The LCD monitor is also a great feature when you are traveling, whether locally or abroad. That sunset over the Grand Canyon or that trip to Europe may not come again. Fortunately, with a digital SLR, you can check your photos while you are still in that location and correct problems, or even take additional pictures inspired by what you have or don't yet have on your memory card.

While similar in features, every digital SLR has its unique characteristics and form. You need to see and hold a camera before making a final decision on its purchase.

A Learning Tool

If you are new to photography, or maybe you're newly returned to it (a lot of baby-boomers are rediscovering photography with digital cameras), the LCD monitor is a terrific learning tool. Wonder what a photo would look like with a different shutter speed? Try it and see. Want to experiment with depth of field? Take a few photos at different settings and make the comparisons immediately. Been afraid of using flash in unusual ways because the results were so unpredictable? Be afraid no more because you'll see the results in a flash as well.

Take as Many Pictures as You Like

This is a big one. How often have you heard people say, "Don't waste your film" on something? It's true, you really can waste film. Film becomes a real numbers game as you are shooting. It can be a cause of stress ("I hope I have enough film") or even something to brag about ("I shot 20 rolls of film on my last vacation.") Regardless, with time and cost considered, there are a limited amount of photos you can take.

Sooner or later, the thought comes up that a particular shot isn't worth doing because it uses up film. Then, consider that most people take extra photos because they want to be sure they got at least one good shot, so the finite pool of film gets smaller. You might not try the creative experiment because it will waste film. You don't try unusual pictures because if they are bad you have to face it when the film is processed. Don't try new angles when

No excuses—You still need to pay attention to:

- **Light**—Without light there is no photograph, regardless of the recording medium

- **Exposure**—No computer can make a badly exposed image look as good as one that was shot right in the first place; blacks, whites, and mid-tones must be captured correctly or the image can become unusable

- **Sharpness**—Good lenses and proper techniques ensure the best sharpness. Image processing programs do have sharpening tools, but these are designed to pull existing sharpness out of a photo—they cannot make a fuzzy image sharp.

- **Depth of field**—This is affected by the point of focus, the lens in use, and f/stop, not digital technologies. It is true that depth of field is affected by the format size, whether that is the old APS film or a small digital camera sensor, because these media use shorter lens focal lengths for equal image size, which result in more apparent depth of field.

shooting a scene—maybe someone else will see them when the film is processed and think you're stupid. These are some of the fearful "don'ts" that can keep photographers from trying new, creative possibilities with their images.

Remember, once you have your digital camera and a memory card, there is no cost to trying new things. With large cards, you can shoot a long time without even thinking about it. No rolls of film to end, no "time out" to change them. You can try something different, see what it looks like, and then erase if it is awful. When you do, it's gone, never to be seen again by anyone. Yet, you might learn something from that awful shot that you wouldn't have had you never tried it. There is also the potential for discovering something new and exciting that might not have been discovered without the chance to freely experiment.

Even smaller memory cards have benefits. You can still experiment—just get rid of the junk as you go. You will shoot a lot less of the "hope-it-works" photos because now you will know if it works or not right as you take the picture.

• Digital is Different

Today digital cameras are so common that it's hard to believe there was so much controversy during the "early days." Digital photography scared some people. They asked: What does it mean? Where will it lead? Would they have to learn a totally new technology? Do you have to learn a whole new way of taking pictures? Is digital something totally different than film? Will it replace film? Will it even replace "photography"?

Unfortunately, early digital camera designers didn't help. They created devices that looked more like Star Trek props than anything that humans recognized as cameras. Their excuse was that film was no longer needed, so why design a camera based on old film models? This was a rather arrogant approach, since cameras are traditional icons in people's minds and because the traditional camera does have a very functional design for photography. These odd looking digital cameras basically appealed to hard-core computer techies.

Another problem that affected the perception of digital cameras was the marketing of early models. Marketers hyped these cameras as featuring "high resolution," which they didn't have. They had terrible resolution, and this poor marketing soured many people on digital photography.

One last hurdle for getting people to switch to digital cameras was that many photographers and technical know-it-alls started using pure math to describe what was needed in a digital camera to match film. Based on their numbers, it looked like digital cameras had a very, very long way to go to match film. Many of us in the photo business also got caught up in that argument, until we started seeing real results from cameras that started adding some power to their megapixel counts. The photos looked great! Sure, if you put one up to your nose, you could see imperfections, but few people other than obsessive photographers look at photos from nose-length away.

We all discovered that you could make superb prints from less pixels than the math whizzes had predicted—photos that totally matched 35mm at a particular size. Size of an image, by the way, is always an important issue with digital cameras. Resolution is quite incomplete and rather meaningless without a reference to how an image will be used and the size at which it will be presented. Now we are seeing outstanding 16x20-inch prints from 6 megapixel cameras. The ideas presented in this book can help you do that too.

In many ways, digital photography is identical to traditional film photography. Both

Film and digital SLRs now look remarkably similar. They handle the same for most photography, but digital cameras offer new features to make your photography even better.

use cameras that consist of a light-tight box with a lens to focus an image onto a light-sensitive medium. Both have something to control the light coming in (exposure) and a way for the photographer to compose the image (a viewfinder). However, some things have changed. There are new terms such as "sensor" and "white balance." These are some new things to think about when using your camera.

Film vs. the Sensor

Your digital camera's sensor is like film since both are light sensitive. However, a big difference is that film reacts to the light and stores the image on its light-sensitive surface. With digital, the sensor "reads" the light, but the camera translates that information into digital data for storage on a memory card.

While interesting, these facts are less important to the photographer than understanding how a sensor responds to light in a way that is different than film. Film "sees" detail equally when the light is in the middle of its range (where that middle is for a given scene depends on exposure). But then, film changes in the way it captures tones in the lightest and darkest parts of the image, creating a very smooth tonal range into those areas.

Digital cameras, on the other hand, tend to see light more in a linear way. They typically capture tones in the same relationships throughout the exposure range, and there is much less of the tonal gradation seen in film's bright areas. Bright highlights in digital images often exhibit a sharp cut off in tones as white is approached. Camera manufacturers have tried to combat this by using special algorithms with in-camera processing and that can help. However, the abrupt cut-off of detail in very bright areas is often a give-away that a digital camera was used.

One practical result is that overexposed highlights are quickly lost and have no detail with digital cameras—like slide film with highlights. Digital cameras do, however, frequently find more detail in dark areas than slide film, making them react more like print film in the darker parts of the image. Expect to lose detail in bright areas that get too much exposure. You will also be surprised, if you are used to slide film, to see more detail in the shadows (although these may show more noise than elsewhere in the photo.)

No Film To Carry

A 640 MB memory card will typically hold over two hundred high-quality JPEG images from a 6 megapixel camera. That's the superficial equivalent to five rolls of 36-

exposure film—all in a card smaller than a matchbook. But a memory card actually replaces much more. How many extra photos do you take when shooting film just to be sure you got what you wanted? Photographers shooting slide film will often shoot 3-4 times the number of actual subjects. Print film usage tends to be less, but for serious photographers, it still can be twice the actual number of different compositions. So now we are looking at 10-20 rolls of film (and think of the space that takes up) compared to one little memory card. Sure, RAW files will take up more room on the card, but people who shoot RAW typically have cards with more memory anyway, so they still carry much less than film users.

Photographers used to taking lots of film with them on trips now find they have extra room in their bags—sometimes a lot of room. They can take smaller bags with them, which are easier to put in an overhead compartment of a commercial jet.

That brings up another advantage—fewer security problems. Passenger security machines in the U.S. usually inspect film without creating problems, but the big equipment that scans checked luggage will damage film. So photographers have to carry film with them, and that can add significantly to carry-on bags. In addition, multiple passes or high film speeds may result in fogging. In other countries, the effect can be worse. Film and security can be an annoyance or a disaster.

Enter the digital camera. A few small memory cards take up no space and are easily taken with you as "carry on." Gate security machines have no affect on memory cards. I've heard conflicting reports on whether or not the big checked luggage machines cause problems with memory cards, but why even chance it? The cards are small and cause no security problems, so keep them with you to ensure your photos are not lost in transit.

White balance is a feature commonly found on digital cameras. It allows the photographer to tune the camera to the color temperature of the light source in the scene.

White Balance Control

White balance is a very big change from shooting film, and the benefits of this feature are great. We'll be spending a bit of time on how to best use white balance a little while later. In this chapter, we're going to look at how white balance changes the photo experience—compared to film. To understand white balance, it is important to know that light changes its inherent color depending on a number of factors. The result is that light from daylight is different than light in the shade, which will be unlike light from an incandescent light bulb. Yet, our eyes and brain do something quite remarkable and adjust to these changes to make colors look natural.

White balance refers to the capability of a digital camera to adjust its sensitivity to the color of light so that the camera responds more like our eyes. Thus making white and other neutral colors neutral and the rest of the colors more natural. The camera isn't quite as tolerant as our eyes, so slight variations in a scene's light can affect it. Still it does work quite well.

With the rare exception of some higher-speed color negative films, where prints can be made with fairly neutral colors, film has no ability to self-adjust to color of light. Typically, film is balanced for only a single color of light, and any other type will make the scene look like it has a color cast. Most

pros will tell you about the challenges of balancing the actual light to the film's built-in response to a specific color of light. Bring a daylight-balanced film indoors and it looks like you dipped the resulting picture in orange Kool Aid. Accurate color for film often required the extensive use of color correction filters.

With the digital camera, all this changed. White balance is a common feature on all digital cameras. Because it is so different than what photographers were used to with film, many photographers think it is a new feature. They may be surprised to learn it has long been a part of video. News videographers have white balanced their cameras as a standard practice since portable color cameras became available nearly 30 years ago.

The digital camera today can examine a scene, automatically check the light for a "proper" white balance, and select a setting for those conditions. More importantly, white balance presets can be chosen to match specific light conditions, or the camera can be custom balanced to the light. In any case, no filters are needed, no light is lost due to filtration, and you can see through the lens with no darkening of the viewfinder from color correction filters. All huge advantages!

Flexible ISOs

Back in the "old days" of film, you bought a roll of film that had a certain pre-determined sensitivity to light. That sensitivity was rated by an international standard called the ISO (International Organization for Standardization) number. This is a standard that is agreed to by countries throughout the world, and therefore, manufacturers.

If an ISO number is assigned to a film, you can count on it having a standard sensitivity or speed, regardless of the manufactur-

er. Low numbers—50 or 100— represent less sensitivity. High numbers—400 or 800—show that a film is much more light sensitive. The numbers are mathematically proportional so that, when two films are compared, doubling or halving a number represents twice, or half, the sensitivity or speed of the film. Once you choose a particular film, you are generally stuck with that sensitivity.

This does not apply to digital cameras. With a digital camera you can change the ISO setting and actually modify the sensitivity of the combination of the sensor and its circuits. It is like being able to change film at the touch of a switch. This is another great advantage of shooting digitally. It allows you to be inside, photographing an actor running for governor with an electronically chosen ISO setting of 800—and you don't need a flash! Then, you follow her into the blazing sun and change to ISO 200 at the turn of a dial. This is a huge benefit, because one camera can handle multiple situations; you don't need to carry along a ton of extra film in case you need the speed of different emulsions. And you don't need to reload or switch camera bodies.

There is one very big difference in film and digital cameras as to how ISO is set by the camera. In most automatic film SLRs made in the past 20 years, ISO is set automatically when you put the film into the camera. A

A true benefit of shooting digitally is that you can choose the ISO to suit the level of light available in each individual scene.

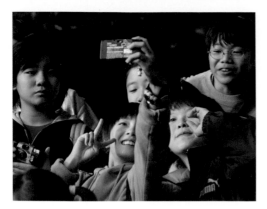

ISOs in digital cameras roughly correspond to the standards set for film. In low light situations it is often helpful to use a higher ISO setting.

DX code (the silver and black pattern) on the side of the film canister tells the camera the ISO speed. This means that you don't have to think about ISO once you load the film, unless you want to manually change to a different speed.

Digital cameras don't work like that at all. You never use film or anything else that has a specific sensitivity to light. You have to choose the ISO. It is true that certain automatic picture control modes on some digital SLRs will automatically choose an ISO, but this is not true for most of them. For standard auto and manual exposure settings on all digital SLRs, you must deliberately choose and adjust ISO settings.

ISO settings in digital cameras are essentially equivalents to film ISOs. A digital camera and its sensor do not have a true ISO that matches film. However, manufacturers have developed ways to make a sensor respond similarly to a film's sensitivity. Practically speaking, if you set a digital camera to ISO 400, you will achieve a response to light that is very close to that of ISO 400 film in a traditional camera.

Unfortunately, the photo industry has not agreed on a standard for measuring this ISO equivalent, which means that the same setting on different camera brands can lead to different exposures. However, the settings are important because they give an indication of sensitivity that closely corresponds to ISO film speeds. Adjusting the ISO allows you to use faster shutter speeds, control noise (grain), shoot in low light levels, have the ability to use slower lenses, and so on.

• Quick Overview— Take Some Pictures!

Understanding these basic elements of digital photography, along with the way you have always photographed with a film camera, will help you to get going quickly with any digital camera.

There are many features and advanced controls available in digital cameras on the market today. The numerous options can be daunting but there are basic features that are common to any digital SLR. Here are the basics of these features.

Most consumer digital SLRs offer a full auto setting, which is essentially a point-and-shoot mode.

- **Exposure** – Autoexposure in today's digital SLRs is very, very good. For many photographers, this is all you need for most photographs, and certainly adequate to get started using a camera. The multi-pattern exposure metering systems in digital cameras do an excellent job in looking over the

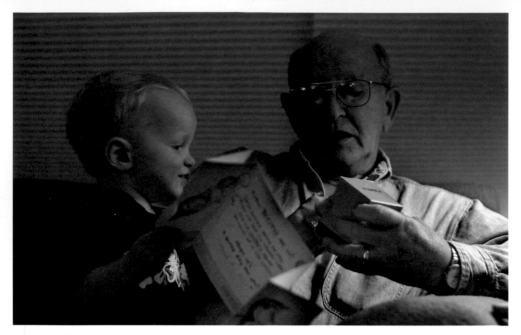

In this picture the camera was set for a high ISO and tungsten white balance to match the incandescent bulbs lighting the room.

image area and giving you an exposure that will frequently be just right for the scene. For basic use, the P or Program setting is probably a good place to start. With it, you can immediately start taking photos with a high percentage of good exposures. In addition, on most digital SLRs, you can adjust the shutter speed and f/stop on a shot by shot basis in P mode for more control. (If you need to do this for all shots, you need a different mode, such as Aperture or Shutter-Priority).

- **Exposure compensation**—Find your camera's exposure compensation adjustment control. This allows you to give a photo more or less exposure a little at a time. With a film camera, you had to guess if you had the best exposure. Now, with your LCD monitor, you have a good idea if the camera gave you what you needed. Review your photo, and then use the exposure compensation to make the

exposure darker or brighter (– or + compensation) for your next picture.

- **White balance**—White balance is something totally new for the photographer accustomed to film. This is a digital technology that allows the camera to adjust for the color of light, so that whites and other neutral colors remain neutral. This is an amazing thing for anyone used to the bad colors that could result when film was exposed under fluorescents or incandescent lights. Now photographs taken under those conditions with a digital camera can look great.

See the Light!

While the camera's white balance control can do wonders in managing color rendition, it won't fix harsh light or light coming from the wrong direction for the subject.

To start, you can leave the camera set on automatic white balance. This lets the camera examine the scene and then employ sophisticated algorithms in its processing electronics to evaluate the image and decide on a white balance to keep colors neutral. This will often work quite well.

After using this setting for a short time, you may notice that it can be inconsistent or may not give results that you expect. The manual preset settings are a big help here and are quite easy to use. These set the white balance to a specific color of light. Many photographers prefer the warmer look of a cloudy or shade setting to the automatic, or even daylight, setting recommended for most outdoor shooting. If you are shooting a sunrise or sunset, the presets will produce better color than auto white balance. Use an outdoor setting, as the auto setting may remove some of the desirable warm color caused by the low sun.

- **ISO**—Film photographers were always limited by film-speed issues. Once a film was chosen and put into a camera, you were stuck with it. Changing films to change film speed was possible, but a major pain.

Now with your digital camera, ISO sensitivity can be adjusted anytime you want on a shot-by-shot basis. You can use a slow speed outdoors, instantly change to a fast setting when you step inside, and then change again when you go back outside, again. Experiment with your camera and see how adjusting the ISO affects the rendition of the scene.

- **The LCD monitor**—Using your LCD monitor offers a huge benefit over film. Some photographers seem to be afraid to use it because it does drain your batteries. Take my advice: the advantages are worth it! Buy another battery! This is just too valuable a feature not to use. The LCD monitor lets you see your photos as soon as you

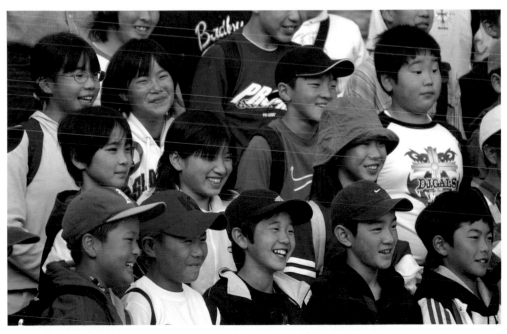

Automatic white balance and exposure can help you capture fleeting moments, such as this group of school kids on a field trip near Tokyo, Japan.

Autofocus systems on digital SLRs allow you to respond quickly to a photographic moment so you don't have to think about the camera.

have shot them. Most cameras will give you a review image on the LCD right after the exposure, but that picture will disappear after a few seconds (or when you press the shutter release). To see all of your recorded images, press the playback button (usually a button with a right facing triangle near the monitor). Use the LCD to check exposure or see what a composition looks like.

- **Autofocus**—The autofocus on digital SLRs is very sophisticated. The number of focus points will vary by camera, but usually the camera will choose the focus point that correlates to the closest part of the subject or scene. Nearly all cameras allow you to select different points as needed. You can usually turn the autofocus on and off (either at the base of the lens or beside the lens mount). Most cameras offer two types of autofocus:

single shot (meaning the camera will not fire if it is not in focus for each shot) and continuous (where the camera constantly exposes film as the autofocus works to keep up with a moving subject.) For most photography, single shot will give the largest percentage of sharp images.

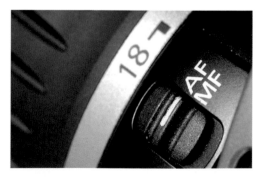

You can always choose between auto and manual focus according to your needs. Here, setting the lens to AF activates autofocus though, on some cameras, the setting is found on the front of the camera body.

• The Quick Guide to Buying a Digital SLR

If you don't already own a digital SLR, read through this book and you'll understand how digital cameras work and what features you may need. Buying a digital camera is a bit of a challenge since they can cost a substantial amount of money. It is easy to lose track of key buying criteria in the heat of the moment. So, I have put together a quick list of things you might need to know. Hopefully it will help trigger important thoughts, so that the choices don't overwhelm you.

I recommend buying from a camera dealer who has experience with digital cameras. There are many nuances to each camera that a good salesperson will know. Many features on cameras have no standardized form, so this can be important.

Camera Shopping Considerations

1. **Megapixels** – Remember that resolution mainly affects how big your images can be. More megapixels will capture more details but, unless the photo is made into a large print, they might never be seen. If you don't need the megapixels, don't kill your budget by buying a 10-megapixel camera when you can buy a less expensive 6-megapixel camera with equal features and quality.

2. **Camera system**—The various manufacturers of digital SLRs offer completely different systems of lenses, flash units, and other accessories. You must think about what you need before going with a particular brand, to be sure the system has what you require. If you already own lenses of a particular SLR brand, this may be a key criteria for a new digital SLR. On the other hand, your existing lenses may not be fully functional with the new camera (or may not give you what you want in your photography) and a different camera system may be better suited to you.

3. **Internal processing**—Unless you want to only shoot RAW files, you should look at how a camera processes images before recording them as JPEGs. Data from the sensor will be processed by unique computer chips in the camera that can affect things like color, digital noise, speed and more. Unfortunately, this processing isn't always easy to discover, so look carefully at the literature of the SLRs and ask questions of the salesperson

 Hint: I recommend shopping at a camera store or other knowledgeable retailer. You want the most accurate information possible before making this major purchase.

4. **How does it handle**—This is extremely important. How do you and the camera fit together? You have to hold the camera. A chart of features will never tell you this. I fell in love with the first digital SLR I ever purchased because of the way it felt in my hand. But it wouldn't fit everyone. There is no question that you will use and enjoy the camera more often if you like the way it handles.

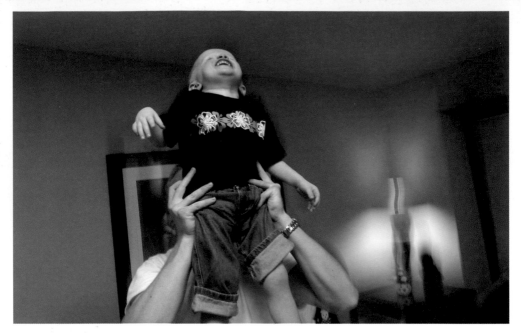

One advantage offered by digital cameras is the ability to set your ISO according to specific conditions. Set it at 400 or above for indoor shots, then step outside and lower it to 100 or 200.

5. **Ease of use**—Not all the controls on digital SLRs are consistently placed or use the same dials or buttons. Since we all handle cameras in different ways, how easy these controls feel to you will be quite subjective. This goes back to handling the camera. You need to experience how easy it is to find and use the controls. Check to be sure the menus are clear and easy to read as well.

6. **Features you need**—Think seriously about the photography you are most likely to do. This book should give you some ideas on what features will most likely affect your use of a camera. You may find that your needs demand special features controls or camera layouts. Pay attention to these needs because they will affect how well you can use your camera. Special features that may need particular attention will include special focusing screens, built-in flash, second-curtain flash sync, slow flash sync, Bulb exposure and so on.

7. **LCD**—We've spent a lot of time praising the LCD monitor because it makes the digital experience work so well. Turn it on and be sure it has decent brightness and contrast, offers good color, and is easy to view.

8. **Size**—Pro digital SLRs tend to be big and the lower-priced "amateur" models tend to be smaller. If you don't need the features of the pro camera, you may find the smaller amateur camera works better for you.

digital SLR features and functions

Digital SLRs are based on 35mm, inter-changeable-lens SLR design and share many common features, no matter what the brand, although the presentation of these features often varies. Camera designers seem to be determined to do things differently than the competition, even when the controls are essentially the same. There are key features that you should know about that will help you better understand how digital SLRs work, how to evaluate different features when comparing models, and how to get the most out of your camera.

• Types of Digital SLRs

Manufacturers typically put digital SLRs into marketing categories: pro cameras, advanced-amateur cameras, and family or mass-market cameras. However, it so happens that pros will use all types and there are many amateurs who use the pro cameras. These are categories that manufacturers use to separate and define the market, so they can produce cameras that meet the needs of many types of photographers.

Pro Cameras

The "pro" camera is designed to a set of specifications that will appeal to a hard working pro. This is typically a camera with an all-metal body, a construction designed to meet the demanding use by a news photojournalist, who is constantly photographing in a wide range of conditions. They require features like: a fast system that allows photos to be taken at rapid speed, advanced sealing against moisture and dust, highest-speed autofocus with multiple focus points. The disadvantages of such a camera are that it can be heavy and bulky, is generally quite expensive, and the controls are not designed for ease-of-use by casual users.

Advanced Amateur Cameras

Cameras marketed to the advanced amateur typically include: all-metal bodies, with construction to meet the needs of a heavy-use amateur, moderate moisture and dust sealing (not weatherproof, which means it can have a built-in flash), moder-

ate camera speeds, and high speed auto-focus with fewer focus points. Their disadvantages are that they are not intended for tough daily shooting and are usually slower than the "pro" cameras.

Mass Market Cameras

Digital SLRs for the family, or mass market, are designed to be small, easy to use, and relatively inexpensive. They typically feature high-quality polycarbonate bodies with metal parts at stress points (such as the lens mount), construction intended for the moderate use by a family photographer, reasonable moisture and dust sealing (not weatherproof, which means it can have a built-in flash), simplified features designed for ease of use, slower camera speeds, and slower auto-focus with fewer focus points. Among their disadvantages, they are made for lighter use, their special pro features are limited, and they are usually the slowest digital SLRs on the market (although the latest digital SLR of this type could be as fast as a previous generation pro model). The biggest differences from the low-end digital SLR to the top pro model relate to speed of the camera, durability for heavy use, and autofocus capabilities.

What Are You Paying For?

It is a mistake to buy the most expensive camera simply because price implies that it is "the best." This can mislead you to purchase a camera that is not what you want or need. For example, I am not personally fond of the pro cameras because they tend to be big and bulky and they are expensive for what they offer. I don't need photojournalist durability or the highest speed camera. I really like the small, lightweight cameras on the lower end. Of course, newspaper pros may find that the only camera they can depend on in the roughest conditions is a high-priced, top-of-the-line pro model.

• Formats & Focal Lengths

Digital SLRs today come in three different formats: full-frame 35mm, reduced frame 35mm form, and 4/3 (a smaller format used by Olympus). Despite these different formats, most digital SLRs use the same lenses as their 35mm counterparts. However, when the format of the camera is a smaller size than full-frame 35mm, lenses change in their effective subject magnification.

Digital SLRs have now reached a price that makes them affordable for a large number of photographers, making them an excellent choice for everything from portraits to landscapes.

Since 35mm is the most common format for an SLR, a lot of photographers have figured that sensors should match that size (making lenses perform as expected with 35mm). At this state in digital camera technology, such a feat is difficult and extremely expensive.

Some people have advanced the misguided idea that the smaller digital SLR formats are just cropped versions of the 35mm size and thus offer no real benefits. Others try to use an "objective" (and also misleading) definition of optical magnification to claim that there is no such thing as a change in magnification. So we need to look at formats to see what they mean to the photographer and how this can be important to you.

Film Formats

Formats in film are based on size differences of the actual negative frame in the camera. The old APS format is the smallest

commonly used film format and 35mm is bigger. There are medium formats (120 or 220 film) and large formats (4x5-inches and bigger). Each format requires a larger camera and a different use of lenses. For example, a 135mm lens is a wide-normal focal length for a 4x5-inch camera, but a telephoto for 35mm. Normal is considered to be a lens that sees the world with a similar perspective to our eyes when looking at a subject from a moderate distance. Examples: 105mm is normal with 6x7-medium format, 75mm is normal with 645, and 50mm with 35mm. Although 75mm is a normal focal length for medium format, it is extremely wide for a 4x5 and becomes a slight telephoto for a 35mm camera.

The focal length never changes, yet the magnification of the subject within the format does change. In theory, you could take a 75mm lens made for wide-angle use on a 4x5, put it on a 35mm camera, and see a telephoto effect on that format. The 35mm only captures a small portion of what the 75mm lens sees for 4x5.

The highlighted rectangle shows the approximate field covered by the digital sensor as compared to the larger 35mm frame. With a telephoto lens, the subject appears larger in relationship to the frame of the digital format. Thus, telephotos have a greater effective magnification when used with the smaller digital format.

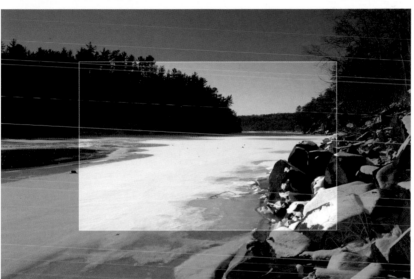

Because of the smaller area covered by most digital sensors when compared to 35mm, a wide-angle lens loses wide-angle capability on many digital SLRs.

The same thing happens with the smaller format digital SLR cameras. These are much smaller than 35mm, so the same focal length—used on 35mm—will give a different enlargement of the subject in the active area of the sensor. This can vary from 1.5-1.7x magnification to 2x in the case of the 4/3 sensor.

Focal Length Equivalents

The result is focal length equivalents. You could say that a lens with a focal length of 35mm, for example, would be a "normal" lens for a digital camera, but that tends to be confusing for most 35mm users. Anyone who has used 35mm film cameras for even a little while has an idea of what focal lengths mean in that format—what's wide, what's telephoto, and so forth. So the industry uses a convention of explaining focal lengths for the small digital sensor format as "equivalent 35mm focal length."

We'll use 1.5x for our multiplier, because the math is easy and it is common to many digital SLRs. A 100mm lens on a digital SLR

Wide-angle lenses give a wider area of view, a greater depth of field, and strong perspective effects.

with this factor will act like a 150mm lens on a 35mm camera in terms of magnification of the subject on the sensor. A 200mm gives the equivalent of 300mm.

This is all great news for anyone shooting with telephoto lenses. You can now get the effect of long, expensive telephoto lenses used for 35mm cameras with much smaller, less expensive lenses. For example, think about a high-quality 200mm f/2.8 lens used on a small-format digital SLR. It now offers the equivalent magnification of a 300mm f/2.8 lens on a 35mm film camera. The 200mm f/2.8 lens is half the size and easily one-quarter the price of the 300mm f/2.8 lens.

The Wide-Angle Limitation

On the downside, this effect does limit wide-angle choices. A 24mm lens on these digital cameras acts like a 35mm lens, providing much less of a wide-angle view. Yet buying full-frame 35mm lenses in very wide focal lengths is expensive, and the

lenses are big and heavy. A number of manufacturers are now designing special wide-angle lenses for small-format digital SLRs. These lenses do not cover the 35mm format, so they can be made smaller and less expensive.

• The Sensor

The sensor is a key element of any digital camera—it is the light-sensing part that first reads the image focused by the lens. It must act like film by having a wide tonal range, by working well in both bright and low light, and by meeting the same ambient temperature, exposure time and ISO speed requirements. It should produce clean, attractive images without digital artifacts (details added by the technology that were not present in the scene. For example, film grain is an artifact of film).

Today's sensors are really remarkable engineering feats but, because they are so technical, they can be difficult to completely discuss in a book like this.

These are two actual image sensors from digital SLRs. The one on the left is a full-frame 35mm type; the other is a more common small-format sensor.

Understanding some of these details is more important to an engineer designing a digital camera than to a photographer using one. But I will give an overview of sensors so you can better understand how they work in a camera and what the different types offer.

First, all are composed of an array of tiny light sensors made of photodiodes—the pixels that produce electricity when stimulated by light. They are then connected by sophisticated technology that interprets and amplifies the signals coming from different pixels in order to build a photograph. All sensors are physically slightly larger than the "effective pixels"—the actual area being used by the camera for photography.

Color Capture

Color is captured in a unique way. Each pixel senses the amount of light in terms of black to white, but not color. A pattern of tiny filters is laid over the pixels so that they can then "see" colors. Most sensors use what is called a Bayer pattern. This pattern is 50 percent green, 25 percent red, and 25 percent blue. It looks like a checkerboard of green (where the black squares would be) and alternate red and blue (for the red squares). Scientists developed this pattern based on the way we see light and color and it works very well.

However, there can be a problem with this pattern, because not every pixel sees all three colors (red-green-blue or RGB). Potentially this can result in color inaccuracies and color moiré patterns in very fine

Color is actually "seen" by the sensor in black and white, but red, green and blue colored filters in the form of a checkerboard Bayer pattern allow the camera to build the correct colors in an image.

Because digital SLRs use larger sensors than most point-and-shoot digital cameras, they usually produce better results in low light situations.

details. Practically, this is rare thanks to very sophisticated filter technology (low-pass filters in front of the pixels) and camera false-color reduction algorithms developed by sensor engineers.

A company called Foveon developed a special chip that avoids this color issue entirely by creating a sensor with layers where every pixel (light-sensing photodiode) will see all three colors. The result is a sensor that, theoretically, can define color details better. Sony recently created a unique sensor with four colors, red, green, blue, and emerald that is supposed to render colors more accurately. The success of these two technologies is hard to predict, but to date, neither has displaced the Bayer pattern as the color technology of choice for sensors.

Sensor Types

Two types of sensors are presently available for digital cameras: CCD (charge-coupled device) and CMOS (complementary metal oxide semiconductor). When digital cameras first came out, CCD sensors were the only choice available to camera manufacturers. This type of sensor has a history of solid performance, consistent production, low noise, and a high signal-to-noise ratio (which is good, as it means less noise in the image). Their disadvantages have been high power consumption, higher production costs, and challenges in achieving high speeds.

Since they were so much cheaper to produce, CMOS sensors promised a real breakthrough for digital cameras.

However, their quality was extremely low at first and they had a poor record with noise. Canon overcame the low-quality CMOS barrier with the EOS D-30 in the year 2000. Since then, the company has perfected this technology, so that today's photographic CMOS sensors offer quality equal to that of CCDs, with high signal-to-noise ratio (low noise by the use of on-chip noise reduction technologies), and low power consumption. The Foveon chip is also a CMOS sensor.

Mega-Confusion

Many photographers have noted that small, compact digital cameras can have sensors similar in megapixel size compared to that of a digital SLR. Yet, there are differences that go beyond megapixels. The digital SLR camera design can handle a sensor that is physically bigger than the sensors in more compact cameras. Even if the megapixels are the same, there are some advantages to the larger sensor. With its bigger photodiode sensing pixels, the SLR can adapt to a wider range of light, giving it more latitude in exposure. In addition, with such a sensor, more light is gathered by each sensing element, so that it has less of a noise problem. The bigger camera will consistently produce a cleaner, better-looking image, especially with high ISOs in low-light conditions.

• Camera Speed

When you consider camera speed, there are five separate issues involved: boot-up time, shutter lag time, speed of capturing

Camera speed, which is influenced by many factors, is an important consideration when choosing a camera for sports photography.

sequential photos (the "drive" speed), number of images that can be taken before the buffer fills, and how fast image data is written to the memory card. All five factors play a part in how quickly a camera can take pictures.

What Determines Camera Speed?

- Boot-up time

- Shutter-lag time

- Drive speed

- Buffer capacity

- Memory card speed

Boot-Up Time

This is how long a camera takes to get started when it is turned on. This speed has come down dramatically since digital cameras first came out. Still, a camera does need some time to get all its circuits going. Perhaps there will be instant-on

cameras in the future, but for now, this is not possible.

While you cannot change a camera's boot-up time, you need to be familiar with how long it takes for your camera to be ready to shoot. If you are photographing any activity that changes constantly, such as a sport where the action is sporadic, you need to be sure your camera is ready to shoot when you are. Since digital SLRs do not have a power-robbing LCD on all the time, you can set your camera for several minutes (or longer) before it goes to sleep. This means the camera will be more likely to be instantly ready for shooting rather than having to wake-up after going to sleep. There is nothing more aggravating than bringing the camera up to shoot an important event unfolding right before your eyes and missing the shot, because the camera has to re-boot.

Shutter-Lag Time

Today's digital SLRs have very little lag time—the time between when you press the shutter-release button and when the shutter actually goes off. In small, compact

The capacity of your camera's buffer determines how many shots can be taken in sequence. Be aware of your camera's limitations while waiting for your subject to make its move.

digital cameras this can be a significant issue, with the time delay affecting what you can shoot. However, the lowest priced digital SLRs also have a very slight delay, which can affect how you photograph high-speed action. You have to either anticipate the action (shooting a beat early) or you can try using the continuous shooting function and shoot through the action (hoping to hit the right point). The high-priced, pro digital SLRs have no significant delay.

"Drive" Speed

In a film camera, the speed at which a camera can take pictures is a function of its motor drive. This feature in a digital camera is often called "drive" speed, although there is no drive involved. The speed depends on how fast the camera can capture the data from the sensor and move it to the internal buffer (the buffer is built-in memory where image data is stored until it can be downloaded onto a memory card—this is all done automatically). With more megapixels in a camera, this becomes an increasing challenge due to the amount of data involved. Low-priced digital SLRs typically have speeds of 1-2 frames per second, while specialized pro SLR cameras, designed for action, can shoot as fast as 6 frames per second or more.

Buffer Capacity

Once the camera's internal buffer is full, the camera must stop taking pictures until space is cleared (when data is transferred to the memory card). For example, you hold down the shutter and the camera takes photos one after another until it just stops—this is normal. On the least expensive cameras, the buffer is small and you might only get 6-10 photos before the camera stops. On high-end cameras made for action, this can be 40 shots or more.

Memory Card Speed

This can affect how quickly images get cleared from the buffer, but, for any real effect to be seen, the camera must be designed to handle that speed. On low-end digital SLRs there will be minimal effect, if any. (Unless you compare an old, very slow card with a high-speed card of today). On the fastest cameras with high buffer capacity, the speed of the card can make a significant difference in how many photos can be taken before the camera stops to catch up. Memory card speed has no effect on how fast a camera actually takes pictures.

• Autofocus

Autofocus (AF) is an amazing technology and a relatively modern development in photography. Cameras today, both film and digital, do some incredible things to focus quickly and accurately on the subject. Cameras have a unique AF sensor (usually a CMOS sensor) that examines a scene and then works with a microprocessor to determine the best place to focus.

Autofocus in a digital camera has a number of important attributes: speed, number and location of sensors, single vs. continuous focus, transfer of focus among sensors, and AF light sensitivity. Although advanced cameras usually perform better, this is not simply a matter of camera price, since newer AF technologies have allowed a brand-new, lower-priced camera to beat an older, more expensive camera.

Speed of autofocus in combination with lens technology affects how fast you can shoot. More expensive lenses frequently have special, high-speed motors that will definitely make the autofocus work faster. Today's digital cameras have autofocus systems that will easily support these lenses.

Speed of the camera is affected by the type of autofocus selected—single or continuous. With single-exposure autofocus, the camera will not take a picture unless the autofocus has focused on

Critical action can be captured with digital SLRs because they have little to no lag between the time when you push the shutter-release button and when the shutter actually fires.

If your camera isn't finding focus, try reframing it slightly so that key parts of the composition are covered by the AF sensors.

something. This is fine for most subjects, but not for moving objects. With the latter, you'll often get frustrated because the camera won't let you take pictures when you want to. Continuous focus lets the camera shoot as it is focusing. The camera will use predictive AF to keep up with the action. That may mean a few out-of-focus shots (where the AF is trying to catch up), but usually, the camera will find focus as you shoot. Some cameras have a third setting for AF—one that automatically switches between these types of autofocus. (Some low-priced cameras use this exclusively and you cannot choose any other setting yourself).

Focusing on the Action

Action can be the most challenging part of autofocus. When shooting action, start the camera's autofocus mode by pressing the shutter lightly (or pushing a special AF button on the camera body) before you need to have key focus. If you wait until the

exact moment required to set focus, the camera and lens may have trouble finding it by the time you need to take the picture. High-priced cameras typically have very good movement-detection systems that follow an object from AF sensor to sensor, even if something new gets in the way (such as an official running across the field of action).

AF Sensor Location

Location of the actual sensors in the image area also affects how well the autofocus will work. More advanced pro cameras designed for news and sports photographers have a large group of sensors that essentially blanket the viewfinder, making it difficult for the subject to elude detection. Low-priced cameras may have as few as 3-5 sensors, which can make it harder for the camera to find and lock focus. In this case you may have to do more work by moving the camera slightly to be sure a sensor finds focus.

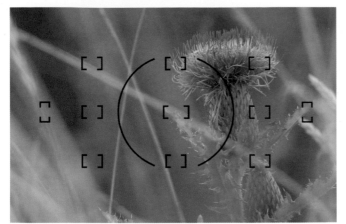

Autofocus & Low Light

One last question to consider when using AF is, "how bright is the setting?" Low light levels can make it difficult for the camera to autofocus. This can also happen when slow lenses combine with teleconverters that limit the light reaching the AF sensors. Many cameras emit AF-assist beams in dark conditions.

Think Before You Beam!

AF-assist beams can be inappropriate for use in some situations, where a bright light in the dark would be rude or even dangerous.

• Metering

Good exposure is important to any type of photography. The meters in modern cameras are superb and create automated exposures that give excellent images for a high percentage of photos. Even today, some photographers claim that the only way to get a good exposure is to shoot manually and interpret the meter reading yourself. Years ago, I used to think that way, but after I started using automatic settings regularly, I found they helped me work faster and more accurately. Worrying less about exposure, I could respond more to the subject and the composition. Not wondering if I would get a good exposure, I could experiment to get the best exposure.

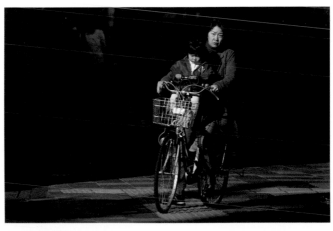

Moving subjects can be tracked with autofocus systems, but to achieve optimal focus you have to start tracking the subject before you actually shoot the picture.

Still, to get the most from your camera there are some things you need to understand in order to make the best decisions about autoexposure, since it works best with some thought and control from the photographer. And you have a great, helpful tool in the digital camera—the LCD and its accompanying histogram (details shortly). You can always check your picture to see if its exposure works for you or not. While the LCD is not a perfect rendition of exposure, with practice you will learn to interpret your camera's LCD in order to get a quick, overall judgment of exposure. For more detailed information on metering and the LCD, see pages 41-42.

Digital camera manufacturers have never agreed to a specific ISO standard. Yes, they will compare their settings to real film speeds, but results will still vary. This is why you may find that two brands of cameras can have the same ISO settings, yet have slightly different exposure readings. Experiment with your camera to see if any adjustments are needed to compensate for your way of metering and the ISO setting. I find that some of my cameras require an exposure compensation setting of one notch lower than the middle, or straight, meter reading of a scene. Let's look at how you can use this information to choose a setting:

ISO Settings

ISO is a standard set by the International Organization for Standards, which specifies and maintains standards for film speed in the industry. However, in common photographic use, ISO has come to be synonymous with the term "film speed."

Technically, since the sensitivity of a sensor/camera combination can be altered, digital cameras do not have a true ISO sensitivity rating. Instead, they have ISO equivalency settings. These do make the camera react like the ISO of film, where a 100 setting is half the speed of a 200 setting. But the sensor doesn't change, only the circuits reading the sensor data. They alter how the data from the sensor is read, so that different ISO equivalents can be used.

This gives photographers a huge advantage in using digital SLR cameras. Since the sensitivity is changed in the camera—not by changing film—this offers the photographer the ability to change ISO settings, even on a shot-by-shot basis. You can use a slow speed outdoors, instantly change to a fast setting when you step inside, and then change back again when you go outside again.

ISO Settings Affect

• Image quality

• Shutter speed

• Aperture setting

• Flash distance and settings

Image Quality

Low ISO settings offer very clean images with little to no noise (with digital, noise is a little like film grain). They render fine details and tonalities extremely well. Low ISOs generally produce "clean" images with purer color. So, for optimum image quality, use the lowest ISO speed possible. However, moderate speeds (up a

Lower ISO settings offer good, clean, low noise images, and are best for outdoor photography.

notch from the lowest number) will still give extremely good results with most cameras and may give you more sensitivity when needed. Also, since low speeds often result in slow shutter speeds, you may find you have better photos at higher ISO's, since you can use a shutter speed that guarantees sharpness when hand-holding the camera.

Shutter Speed

Higher ISO settings let you use faster shutter speeds. This can be extremely helpful when handholding your camera, especially with slow zoom lenses (which may offer f/5.6 or slower as the maximum aperture, for example, at longer focal lengths). Faster shutter speeds will also capture action better, while lower ISO settings can be useful for blurred action. Lower ISO's frequently require the use of a tripod because the shutter speeds drop too low for handholding.

Aperture Setting

Sometimes your shutter speed choice is limited, like when you are handholding a camera or the subject is moving. Changing the ISO can give you more aperture options to help you control depth of field. Higher ISOs allow for smaller f/stops and more depth of field in those conditions, while lower ISO settings will require wider lens openings resulting in less depth of field.

Flash Distance & Settings

Any flash unit, whether built-in or added as an accessory to your system, produces a defined amount of light. Its light output affects how you can use the flash: what f/stops can be used with it, how far it will go into a scene, how well it will bounce off a ceiling, if it can be used in a softbox, and so forth. Higher ISO settings give you more range for your flash. Because

If the light is very low, higher ISOs may cause noise to become overly noticeable. Even a small flash unit can help then.

smaller lens openings can be used, light goes farther into the scene and so forth. Lower ISO settings usually make fill-flash easier to use in bright conditions because the exposure won't be influenced as easily by ambient light.

• Noise

Grain has long been a challenge for the photographer. Velvia, Kodachrome, T-Max—all the super high-quality films—had extremely fine grain, which helped propel the small format of 35mm into dominance in the film world. Still, grain can be a distracting problem, especially with faster films. Noise is the digital equivalent of grain. Digital files can exhibit stray data that has nothing to do with the photograph. This extra stuff is called noise. This doesn't always happen—a digital file that has little or no visible noise is said to be a very "clean" image.

But if noise occurs in an image, it will appear as tiny specks of color and light that look a lot like grain in film. These specks can detract from the subject (although in some instances grain or noise can be an interesting effect). Noise can obscure fine detail and alter colors. It may even affect apparent sharpness, since our evaluation of sharpness can be influenced by the sharpness of the noise or grain. Noise shows up most strongly in digital images in the dark parts of a photo, and becomes quite evident when image editing is applied to these areas. The physically larger sensors in digital SLRs have bigger pixels, which results in better light gathering capabilities and less noise. Smaller sensors, often found in compact digital cameras, can potentially exhibit more noise when photographic conditions are not optimum.

When trying to reduce noise, there can be trade-offs. You may need a certain feature of the camera (such as a high ISO) even though it will increase noise.

Sensor noise is most noticeable with higher ISO equivalents (that allow us to shoot in lower light) because they amplify the sensor signal. Dark scenes that require long exposures can be a problem, although the latest cameras tend to have very good noise reduction circuits for this condition.

What is the solution? You have no control over the sensor itself, although more expensive digital cameras often control noise better. However, if you shoot in bright light and limit the use of higher ISO numbers (400 or higher), you will minimize the noise in the image from the sensor.

High ISO settings in very low light allow you to capture photographs that might not otherwise be possible. However, the tradeoff is that you will pick up noise. The way you choose to sharpen the image with software will affect the appearance of the noise. High amounts of sharpening may make the subject look sharper, but it will also sharpen and enhance the noise, which might be an undesirable after effect.

Noise Abatement

It helps to understand the key factors that cause noise and their remedies so you can decide how much you can control noise.

ISO Settings

Cause: Noise increases with increased ISO settings. This is similar to the response in film – grain also increases with higher film speeds.

Solution: Use the slowest ISO speed possible. But, if you want to play creatively with noise, try high speeds. This factor is quite variable among digital camera models, so no blanket comment can be made about noise and specific ISO settings. Generally, you can depend on noise increasing with ISO speed, but the amount of noise can only be determined by doing some tests.

Exposure

Cause: Digital camera sensors don't like underexposure. It causes problems because large areas of darkness must be lightened. This makes any existing noise even more visible.

Solution: Be sure you have enough exposure. It is important to expose images well so that dark areas have enough data to utilize.

Hint: You can always darken them in the computer if needed. You want to avoid having to over-enhance them to bring out detail.

Bracket exposure when you are not sure of a scene to ensure you have an exposure with minimal noise. Add exposure, or use a flash, if needed.

JPEG Artifacts

Cause: Too much (high) compression when using the JPEG format in the camera, or repeatedly opening and saving a JPEG image in the computer, can create little blocky details that look like chunky grain. This can be very noticeable in the sky or across any same-colored area that has slight gradients of tone. In addition, higher JPEG compression can accentuate any noise in a photo.

Solution: Set your camera to its finest quality (lowest) compression— even though this does mean larger file sizes. Never try to cram as many photos on a memory card as you can by using the higher compression levels available on your camera. Buy a larger card. Once your images are in the computer, don't continue to use JPEG as your working format. Instead, save your image as a TIFF or the native image processing program format

Digital Artifacts

Cause: A digital camera must make sense of that gradient, like subtle changes in the sky. However, it cannot see pure continuous tonal change, since it only deals with discrete bits of data (pixels) in order to create the illusion of a gradient. This can cause a grain-like pattern in the sky, especially in low megapixel cameras. Although this is not very noticeable at first in the latest digital SLRs, it can have an effect on the image when skies are adjusted in the computer.

Solution: Out-of-focus areas and large expanses of slight tonal changes (such as sky) emphasize grain, because this is exactly where the translation from smooth reality to individual pixels is toughest. Be aware of what your camera can do and, when working on such images in the computer, avoid too much hue/saturation change or sharpening for these areas, since these will accentuate the noise.

If everything in a photo is not supposed to be sharp, why sharpen it all in the computer? Minimize noise problems by only sharpening the parts of an image that need to be sharp.

Sharpening

Cause: Indiscriminate sharpening and oversharpening, both in the camera and in the computer, can enhance grain and noise to the detriment of a photo. All too often, when the entire photo is sharpened, little-noticed grain or noise suddenly gets very ugly.

Solution: When appropriate, sharpen only in the computer and—even then—only the sharp parts of the photo. You might also try setting the threshold higher (3-9 works well and increase the amount to compensate) in the Unsharp Mask tool to reduce the sharpening effect on grain. Skies and out-of-focus areas that have digital grain should not be sharpened. Sharpen selectively by selecting the area that should be sharpened, feathering the selection slightly, then sharpening. You can also create a duplicate layer, sharpen it, and then remove (by erasing or using a layer mask) the parts that should not be sharpened.

Image Processing Software

Cause: Even very sophisticated Photoshop users have overlooked this rather important noise factor. Image processing software can actually increase the appearance of grain or noise due to the use of certain processing controls. Overuse of Hue/Saturation, for example, will dramatically bring out undesirable grain/noise effects in the photo.

Solution: Be aware of your software's preview function and watch for unwanted noise. Avoid over-processing the image's color. This often leads to increased digital grain, because, as the program looks for differences to adjust in your subject, it also sees and enhances the tiny differences in grain or noise.

Heat

Cause: In the fine print of many digital camera manuals, it may say that heat can increase noise. This is one reason why long exposures pick up more noise and need noise reduction technology, because, as the sensor "works" during the exposure, its temperature will increase. But any time the camera is overheated, noise can be an increased problem.

Solution: Keep your camera as cool as you can. Never leave it in a hot car just before you shoot. Sometime, just feel a black camera in the sun to realize how hot it can get. In hot climates, shade black bodies from direct sun to keep the temperature down. You might also consider using an inexpensive cooler to keep the temperature of your camera lower. Don't use ice in that cooler (it can cause condensation), but try a couple of bottles of room-temperature water to keep the inside at a moderate temperature.

Proper exposure, careful use of JPEG compression, and selective use of sharpening tools in the computer will result in a photo with the least amount of noise.

Noise & Grain Reduction Software

Most cameras today have some sort of noise reduction capability. This can be automatic in the way the sensor and its associated electronics work, or a separate feature. Noise reduction can work quite well, but when shooting at long shutter speeds, you may notice that the "processing" time—time between shots—increases because of noise reduction at work.

Let's face it, no matter how hard we try to control it, noise sometimes just beats us. A couple of excellent noise-reduction software plug-ins help reduce noise after the shot: GEM and Dfine. Kodak's GEM is very simple and easy to use (www.kodak.com). Dfine from nikMultiView Media Pro (www.nikmultimedia.com) offers more flexibility and adjustment capabilities, including camera noise profiles (which makes it more versatile, though that versatility gives it a slightly steeper learning curve). Knowing where noise comes from allows you to apply remedial techniques, but you will rarely completely eliminate noise. However, by paying attention to the details above, you can maximize success in your war against unwanted noise.

resolution
& formats

Resolution is critical for the best detail in an image, but it is highly size dependent. The image to the left has only 72 ppi/dpi, nowhere near enough for printing.

This image looks considerably different than the one above. In this case, the resolution is 300 dpi/ppi, exactly right for a photo on the printed page of a photo book.

Camera resolution and image formats have got to be some of the most confusing parts of digital photography. While there is plenty written about these topics, there is also a lot of misinformation. Yet, once you start taking pictures digitally, you must confront these issues. In order get the most out of your digital SLR you need to understand resolution and formats—at least enough so you can make the right choices for your photography.

• Resolution

We'll start with the tough one—resolution. Resolution is especially difficult because the term can refer to at least three different things: area resolution, linear resolution, and printer resolution.

Area Resolution

This refers to the total number of pixels in a digital photo file. This is given as two numbers—for example, 3000 x 2000 pixels. This is directly related to megapixels of a camera. Multiply the pixels in the example and you get a total of 6,000,000 pixels, which equals 6 megapixels.

Linear Resolution

This is the number of pixels per linear dimension—usually inches, which will become ppi (pixels per inch) or dpi (dots per inch). Technically, ppi and dpi are not the same, but they have become interchangeable in general use. Sometimes you may even see them both used: 180 ppi/dpi (180 pixels/dots per inch). Linear resolution is meaningless without a total image size or dimension for reference such as 8 x 10-inches at 180 dpi.

Printer Resolution

This is very confusing since the resolution of a printer—such as 1440 dpi—is a separate function that is set independently of camera resolution. The outra-geous resolutions (4800 dpi or higher) for printers are mostly marketing hype. These will not give better photo quality prints than lower resolutions. We won't be discussing printing much in this book, but you can learn more about printing in books on that topic like the *Epson Complete Guide to Digital Printing*—also published by Lark Books.

Making Sense of Resolution

With a digital camera our first concern is the overall, or area, resolution. This tells us how much data we have to work with. It is very important to understand that resolution is not an arbitrary quality issue. Resolution affects size more than anything else. One misunderstanding is that megapixels equal sharpness. You can have a very sharp image from a 3 megapixel camera and an unsharp photo from a 6 megapixel camera. You can also make 4 x 6-inch prints from 3, 6, or even 12 megapixel cameras and they will look essentially identical in sharpness.

Increased resolution gives you more detail—revealed in larger prints. On a basic level you need approximately: 2 megapixels for up to a 5 x 7 inch print, 3 megapix-

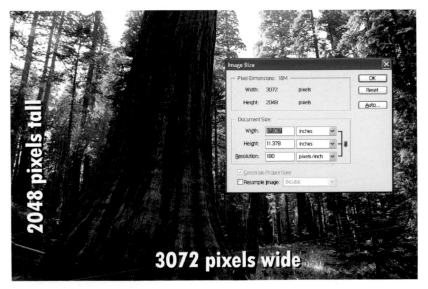

Area resolution is the total number of pixels in an image. Linear resolution is the number of pixels per linear dimension and is usually expressed as ppi or pixels per inch.

Visually, you can quickly see what different resolutions do for a particular image size. The difference between a resolution that is too low (left, 72 ppi/dpi) and one that is correct (right, 300 ppi/dpi) is obvious.

els for an 8 x 10, 6 megapixels for 11 x 14. This is fairly conservative but will easily give true film quality prints from a photo inkjet printer. Since digital camera files can be so "clean" (meaning without grain) they can often be used to create image files that can be printed much larger with exceptional results.

However, you can print larger prints easiest with more digital data—larger digital files that come from cameras with higher resolution. Pros who want to make extremely large prints with very high detail, or who need to create images that can be used at large sizes with the highest quality printing, must use the highest megapixel cameras available today.

Digital photos are typically printed at image resolutions of 200-300 ppi/dpi (this

is not printer resolution, but the actual linear resolution of the image). The variation is due to the way different printers deal with the digital photo and its resolution. Almost all inkjet printers on the market today will print beautiful images with an image resolution of 300 dpi. Most photo printers, however, will give equal quality at 200 dpi (sometimes even less). This spreads out the available pixels and allows for larger prints.

Consider a 6 megapixel camera with area resolution of 3000 x 2000-pixels (resolution is typically expressed with the larger number first). If the pixels are used at 200 per inch (200 ppi/dpi), you will get an image that is 15 x 10-inches in size (3000/200 = 15 and 2000/200 = 10). But, if you had to squeeze the pixels together for 300 dpi/ppi, the results would be approximately

There are three important parts to image resizing: (1) Actual size of the image in megabytes and area pixel dimensions; (2) The printing size of an image with linear resolution (pixels per inch); (3) How the image is sized—resampling actually changes the pixels.

Below, the two screen shots on the left show resizing an image with resampling unchecked (a first step); the two on the right show reducing and increasing an image size by resampling.

10 x 7 inches (3000/300 = 10 and 2000/300 = 6.6)—a significantly smaller photo. How do you know which works best with your camera and printer? Try them both and see.

Unfortunately digital camera manufacturers have not been consistent with how they associate a particular linear resolution

with the camera's images. It would make sense to use a "real" linear resolution like 300 dpi (commonly used in the publishing industry) or 200 dpi (used with printers), but that sort of "sense" is not part of the camera making industry. Some cameras and files will give 300 dpi, but resolutions of 72 dpi and 180 dpi and others are just as common.

Note: The 72 dpi number is especially puzzling. It is a web resolution and never a printing resolution on any type of printer. Try the math: with a 6 megapixel camera you will get an image approximately 42 x 28 inches, which is totally unusable for anything. It won't fit on any web site and it can't be printed with any quality. What were they thinking?

Before printing any digital camera files (unless you are printing directly to a printer from the camera), you do need to check the linear resolution. This is found in the Size, Resize, or Resample choice in image processing software. Some printing programs will do the resizing automatically. You need to do this because an image printed at too high a linear resolution (such as 600 dpi) can actually reduce the quality of the print (the printer is not made for such resolution and throws data out), plus you have to deal with more data than the computer needs for such a print.

Setting the Camera

On your digital SLR, you will see multiple resolutions available. Most of the time you

should use the maximum resolution offered by the camera and stick to it. This delivers files with the most capabilities and you will not be limited to small print sizes. Plus it gives you the resolution you paid for. You can always reduce the size of an image, but increasing it back to a larger size (that it could have been in the first place) will never give you the highest quality.

If your need is only to display photos on the Internet, you may find it easier and more efficient to shoot at a resolution that is less than maximum. This will give you smaller files that transfer faster, take up less space, and can be worked on quickly. If you need display-only photos (e.g., record-keeping photos of household items for insurance purposes), high resolutions aren't necessary.

• File Formats

File formats—the way your camera saves your photos—can also be confusing. Especially since you'll hear some people say you have to shoot one way and then someone else says you're better off shooting another way.

TIFF (Tagged Image File Format)

This is an ideal format for photographs—once the file gets in the computer. But it is not ideal for the camera! TIFF files are uncompressed full-data files that retain image details when used as a working file format in the computer. But they are large

Because you cannot detect different resolution settings in the LCD monitor, you need to be sure you have the right resolution set through the camera's menu or other controls.

JPEG and RAW files each have their advantages and disadvantages. Pros shoot with both, and great photos have been made with both. You need to look carefully at what you want to do with your photography to decide which is best for your needs.

files that slow down cameras, hog memory card space, and offer no real advantage for image capture. This is why most cameras no longer offer this format.

JPEG (Joint Photographic Experts Group)

JPEG is an ISO standard for extremely smart compression technology that offers a small file with superb detail. It does come in different strengths and, while the higher compression "strengths" give small-er files that fit easily on the memory card, those files start to lose important data. JPEG is a "lossy" format which means data is lost as the file is compressed. At high quality (low compression) settings, most of the lost data is redundant and can easily be rebuilt when the file is uncompressed. At high compression levels more data is thrown out—including some information important for displaying tonal gradients and other fine detail. Bottom line: JPEG can work great, but it should be used at the highest quality settings most of the time.

RAW

This type of file uses data with little processing as it comes from the sensor. It is a "full-featured" file in that it offers more color data than a JPEG file. RAW is a 16-bit file format that easily holds the 12-bits of color data that today's digital SLRs offer (a common misconception is that, since a RAW file is based on 16-bit color, it is using 16-bits of data from the sensor; sensors provide 12-bits). JPEG is an 8-bit file that holds much less color and tonal information—especially in the dark and light areas of a photo. RAW files are proprietary for each camera manufacturer. You need special software to read these files and to process them.

The Advantages of JPEG

When you save your photos as JPEG files from the camera, there are advantages and disadvantages. One disadvantage is loss of detail if too much compression is used (the answer is to use the highest quality, lowest compression settings). A JPEG file also contains less color and tonal information than a RAW file. For many photographers, some special advantages of JPEG can outweigh that drawback.

Many digital SLRs have unique processing chips built into the camera that examine the data coming off of the sensor and (using highly refined algorithms) process that information to get the most out of the image as captured by the sensor. These processors will look at the same data that is recorded to RAW files, but do some work on things like tonalities and colors in order to record a better image file to JPEG. In essence the camera smartly converts the 12-bit file the camera is capturing into the best 8-bit file that JPEG can record.

Many digital SLRs have unique image processing chips built into the camera to process the data coming from the sensor and get the most out of it before recording to a JPEG format.

Special Features of RAW

RAW files offer the ultimate in total data to the photographer along with the ability to have complete control over that information. Up until recently this was not as great an advantage as it should have been. There were few software programs available that could work with 16-bit files other than the camera manufacturer's conversion software. This often made RAW work a slow and tedious process—plus the conversion software varied considerably in how much adjustment could be made.

That limitation is no longer true. Manufacturers' software has gotten faster and offers better control. Independent companies have created excellent RAW conversion programs like Capture One from Phase One. Image processing programs, like Adobe Photoshop, can now

Adobe has built RAW conversion capabilities into its latest Photoshop program, which makes conversion quite convenient.

work fully with 16-bit files (they used to have strong limitations).

A big advantage of a 16-bit file is that the extra data increases the capability to adjust the image and reduces the chances that banding (or posterizing) will occur. A JPEG 8-bit file can offer great quality, but if you make major changes to it (considerable adjustments in color or tonality), gaps will occur which cause banding across gradients. When this occurs the tones no longer blend seamlessly and will have obvious looking step patterns. This is much less likely with RAW.

RAW files are terrific when color is off, too. With the extra information to work with, the conversion software can often make better color adjustments. Most RAW conversion software will allow you to change the white balance—just like you were changing it on the camera—in addition to making more

precise color adjustments in actual color temperature or color tints.

If you need really big files interpolated above the camera's file size (e.g., to make larger prints than with the camera's normal file size), 16-bit is also the best way to go. Most conversion software allows you to do this ramping up of size in the software while you are still in the conversion stage, and Photoshop now offers new enlargement algorithms that work in 16-bit. The reason for this advantage is simply data. Remember: More data gives the computer more to work with in interpolating information up in size.

The Epic Battle

So it comes down to this: JPEG vs. RAW—the battle of the digital age. Everyone is weighing in with more than

Camera manufacturers have their own RAW conversion software that usually offers the best in conversion technology, though it adds a step to the photographer's workflow.

simple opinions. Somehow the photographer who is not shooting the "right" way is supposed to feel guilty or fear that his or her photography is declining because of this "wrong" choice.

I had a mentor years ago who gave me some very good advice concerning such things (although he would be amazed that his advice would apply to digital photography). He said that, when faced with people who challenge your ideas, find a real-world example of something that demonstrates your idea in action. So I ask: In the real world do professional photographers use RAW files that end up being published in high-quality applications? Yes. In the real world do professional photographers use JPEG files that end up being published in high-quality applications? Yes.

The point is simple: The publishing world does not generally care whether the image

came from RAW or JPEG. Editors, art directors, photo buyers, and so forth do care about how the image looks, how it communicates to the audience, and how it fits the publication's need (from consumer editorial to advertising). Pros shoot both types of formats for their work and have beautiful images published from both. Conclusion: Both formats work extremely well.

What is important is the photography you do and your way of working. If you were used to shooting quickly with film, JPEG is a good way to go. If you love the darkroom and processing film, RAW is a great continuation of that process. Coping with problematic lighting that needs every little nuance of tone and color? RAW may give you the best results. You have tons of images to handle? JPEG may be the most efficient. JPEG and RAW are not only capture formats, but they are also ways of

What format is best for you really depends on how you like to work. The great thing about digital is that there is no cost to trying out both JPEG and RAW to see what they really offer you.

working (technically, JPEG is a compression scheme and not a true format, but it is effectively used as a format). I have shot for magazines (including *Outdoor Photographer* and *PCPhoto*) with images printed across two-page spreads and completed several books that were produced with digital photos (including *Epson Complete Guide to Digital Printing* and *Magic Lantern Guides: Canon EOS Digital Rebel*). Only a scant few photos in these publications came from RAW files.

The only thing this really says is that I like working with JPEG and can get the publication-quality results I need. Several of my good friends in the nature photography industry would not consider shooting anything but RAW—claiming that

they like extra flexibility they get in processing the image after the shot. They get more exposure latitude, the ability to easily readjust things like color balance and the capability of making higher quality enlargements if the file has to be interpolated up in size.

The key is how you like to work and what results you need. You have to test the formats for yourself and see what works best for you. Don't be intimidated by didactic people who seem to think that anyone who doesn't work the way they do is wrong, stupid, and should be corrected. Whatever choice you make should be based on your real-world photographic challenges. Whichever format works best for you is the best choice.

get the most from your camera

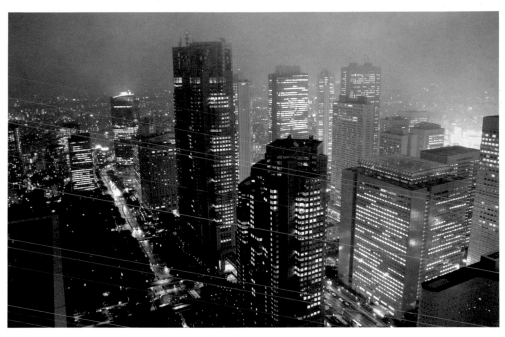

No camera is better than the one in your hand when striking conditions appear, such as this scene taken while at an evening dinner high above Tokyo.

A downside of photography magazines is that they report on all the camera gear that gets introduced. That's certainly good to help photo enthusiasts keep up with what is going on in the industry. The problem is that photographers learn about all the new features that their camera doesn't have (or features in cameras that are unaffordable). I love learning about all the new things that cameras can do, but I also try to evaluate whether they really meet my needs. Do I really need that high-speed camera or is it more suited to the sports photographer? I may shoot my daughter's soccer games—but I don't work for *Sports Illustrated*. So maybe I can do fine with my slower camera.

My feeling is that you should make the most of whatever camera and system you own. If you find that your system does not allow you to get the types of photographs you need, that may be a reason for upgrading to a new camera. It may also be a reason for spending more time with your existing camera— learning to work within its limits. Use your camera—play, experiment, and take lots of pictures. Why not? There's no cost with a digital camera!

Photography can be a great deal of fun with a digital SLR because you can take photos at any time, in any conditions, and not have to worry about buying and processing film.

No matter what you own— have fun with your gear! Think about the master concert pianists—they don't create great performances by only playing in the concert hall. They constantly play with their piano— experimenting and discovering its outer limits. This is why a digital SLR is so great: You can take photos at any time, see them immediately for instant feedback, and yet spend no money on film or processing.

• Camera Parameters

Most cameras can be set to perform beyond the basic default settings for sharpness, contrast, and color. Such options are typically found in the camera menu or custom functions (although your camera may or may not have these particular choices). Some cameras even offer a choice of preset subject parameters for these settings.

In general the standard settings employ moderate contrast and less color saturation compared to film and there is no added sharpening. You can change this by tweaking the contrast and color. For example you can get your camera to perform more like certain types of film. However these settings are applied to the camera before the photo is taken, so they are built into the photographs. You cannot change them later.

These settings can offer some interesting possibilities if you are willing to make changes to the camera's response to a scene. It is annoying when a camera only allows individual setting adjustments, but a number of cameras can save groups of settings as new parameters or custom functions.

Playback menu
Shooting menu
Set-up 1 menu
Set-up 2 menu
Tab

Quality	Large
Red-eye on/off	Off
AEB	⁻2..1..0..1..2⁺
WB-BKT	...
Beep	On
Custom WB	
Parameters	Parameter 1

Menu items Menu settings

Take Advantage of Parameter Settings

- **Personal preferences**—If you find your camera consistently makes photos that are not saturated enough, or too warm or cool, check the parameter settings to see if you can tweak it more in the direction of your preference.

- **Direct printing**—If you have a printer that allows direct connection to a camera, you may find that adding some sharpening and increasing color saturation can be helpful.

- **Gray days**—Try creating a setting with more contrast, increased color saturation, and warmer colors to give these days more zip and warmth.

- **Portraits**—You may find that adjustments that reduce contrast, lessen color saturation, and add warmth help with these subjects.

- **Experiment**—Try different settings with favorite subjects and see what the camera renders.

• The Marvelous LCD Monitor

The LCD monitor is the biggest thing about digital cameras that has changed the way we photograph. The ability to immediately see the picture you just shot gives instant feedback on how well you are doing with your subject. You can see if the composition looks good. Was the exposure right? Did the subject blink?

This has even made professional techniques more accessible to all photographers. For example, I used to do studio photography where we shot with strobes (flash). Although the flash had modeling lights, we could never be sure of our light unless we shot some test Polaroids to see what we were getting. The LCD truly is better because you see the real photo in the LCD—not a substitute that has to be retaken with the "real" film. Now anyone can use flash and check the results to be sure they got the shot. And you can use this very real tool at any time and in any light.

The camera LCD monitor has radically changed photography for the better. Now you can review your image instantly and make adjustments on the spot.

This has truly been a revolution in picture taking for many photographers. There is no longer the "hope I got it" attitude. Instead one just checks and re-shoots. Again and again, photographers find that they love being able to respond to both the subject and the photograph at the same time. It allows you to make changes while the subject is still there.

But sometimes the LCD monitor isn't used as effectively as it could be. It can be hard to see in certain light and does require a conscious effort to use it all the time (especially if you were shooting film before). But it is worth the effort. A representative of a prominent camera company surprised me by telling me, "You don't need to check shots…a good photographer should trust his or her craft." I thought, evidently, a lot of pros (like me) are not good photographers, since we do check shots. Why wouldn't we? With digital, it's so easy and you get such valuable information. So why not check?

Here are a series of tips to help you get the most from your LCD monitor:

Nikon

1. **Set the review time.** After you take the picture a digital SLR will typically display the photo briefly on the LCD monitor. I like this reassurance that I got the shot, but the feature can be turned off. The important thing is to set a display time you like. The preset default times are usually deliberately conservative to conserve battery power—usually too conservative for me. I like to set the review for at least 8 seconds. The review will disappear when you press the shutter release slightly.

2. **Learn to see it.** It does take a little practice to be able to see the LCD monitor in all light. Newer cameras have brighter monitors, but you still have to spend time looking at your camera's monitor in a variety of light conditions. With a little practice you'll be surprised how much more you can see and how often you'll use the monitor. Most cameras do allow some adjustment of monitor brightness (this is usually found in the menus). But this can be tricky. Too much brightness makes the screen lose contrast, and details in highlights become hard to see.

3. **Shield the screen from bright light.** A hand, a hat, or your body's shade can all block the light from the monitor and make it easier to see. For serious review of shots find a shady spot. A hat can be a good addition to your shooting kit because it works great for shading the monitor. Several manufacturers also make hoods that attach to the camera— blocking the sun to allow a better view of the tones and colors of a photo. Some photographers even take along a dark cloth (or use their jacket) to put over their heads to shade the screen.

In bright light, you may need to shield the LCD so you can see it better. Don't give up! Learn to use the monitor in all kinds of light.

4. **Learn to interpret it.** This is very important. The LCD monitor has not been calibrated to match your computer monitor, nor is it designed to show you everything important in the photograph. With experience you will be able to make mental adjustments to what you see in the monitor, as you will learn how your camera's LCD screen deals with contrast and color.

 Hint: Use the magnifying button or dial on your camera to enlarge the image as needed so you can better see details (such as sharpness).

5. **See it as a photo.** When looking through a viewfinder, even the best photographers sometimes forget to compose a photograph and instead just frame a subject. The LCD monitor now shows you a miniature version of your image, a nicely displayed photograph on the back of the camera. In some ways the small size of this image can be helpful because it makes you look at how strong the composition, contrasts and colors are in the image.

6. **Watch the edges and other details.** How often have you been surprised to see something creep into the edge of your photo? It happens to everyone. Maybe worse, a distracting sign shows up right behind a tender portrait that you didn't see until the film came back from the processor. In the excitement of photographing some subjects, there is no question that we can miss problem details or things sneaking in around the edges. Check that LCD to be sure you are not capturing things you did not want in your photo. Fixing these on the spot by taking a new photograph is a lot easier and faster than trying to correct them later in Photoshop.

7. **Experiment.** I find that a digital camera absolutely encourages me to experiment, and I love doing it. I no longer have to worry about wasting film, and now I can see the results of my experiments immediately. That way I can make changes or adjustments to get the best photo possible. I can decide that the experiment is not worth much and simply delete it, or save the image for later review. But the best thing is that you can still make changes as you go while you are with your subject.

The LCD monitor gives you a new way to respond to your subject. Now you can compare what you have in the camera with the subject itself to see if you captured the photograph you wanted.

Check Your LCD

Later in this chapter there is a whole section on exposure, but let me emphasize one thing first: the camera's LCD monitor is a huge benefit in getting the right exposure. Studio pros long have used Polaroids to check exposure. They'd take a shot with a Polaroid back (film holder) on their studio camera and then process to check the image for exposure and contrasts. But, even then, they couldn't be absolutely sure, because what was seen in the Polaroid was still not the final shot. They had to then take more test shots and—due to unavoidable variations—photographers would often do something called a "clip test." They would have the lab clip a portion of film, process it and then decide if any final adjustments needed to be made for processing the whole shoot to bring exposure into line.

The LCD screen is so important, I'll say it again! Finally you can check exposure on the real shot! And continue to check as the light changes. I strongly urge you to learn to read the histogram (explained in the next chapter), because it provides another check on exposure. Even if you do not choose to really study exposure—or the histogram—the LCD monitor will always

Double check highlight and shadow areas in your image using the LCD monitor to be sure you have detail where you need it.

give you a good idea of your exposure. While it is not a perfect rendering of what your image will be, with practice you can learn to accurately interpret what you see.

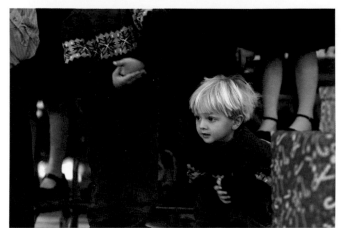

Even during action, a quick review of images can ensure that you are getting the right exposure and composition.

Edit as You Go

The review function of your camera lets you access your photos at any time. This allows you to check them and edit as you go. Some photographers believe that if you edit as you go you may remove photos that might have been keepers. A well-known example of this was a photo of Monica Lewinski and President Clinton, when she was an intern meeting him for the first time. Only one photographer—who kept all his digital files—had the shot.

The ability to edit as you go is certainly very convenient and easy. You simply call up an image on the LCD, evaluate it (including enlarging it to see sharpness detail) and keep or trash it. If you want to safeguard an image so it cannot be easily erased, you can also lock or protect individual shots.

The playback and delete buttons are very important parts of your digital SLR.

Advantages of In-Camera Editing

1. **Exposure and composition check**—Being able to see what your image looks like with your exposure and composition choices is vital. You will quickly know if you are right or wrong, if you should continue with the same choices, or try something new.

2. **Improvement**—Increasingly photographers are finding that looking critically at your photos—as you are shooting—makes your subsequent pictures better and better. Long-time pros have told me this is a big advantage for them and gives them a new-found excitement for their photography. You could keep all the shots after looking at them, but I believe that when you delete the "bad" shots, you not only clear them from the memory card, but the action also clears them from your mind. You can focus on what is working for you, since that is what stays on the card and in your memory.

3. **Clutter**—Think about it: With photos on your memory card that you will really never use, you end up with a lot of junk to deal with later. Where do

Reviewing and editing images while shooting can ensure that you get complete coverage of the situation, from close-ups to wide-shots of the scene.

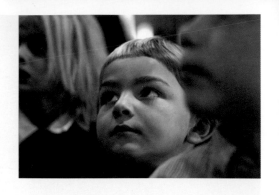

you put them? How do you handle them in the computer? You could toss them into a file on a large hard drive and forget them, but how often are you going to need that obscure photo? For most photographers, having a group of images that really pleases you means you will return to them again and again for printing or other uses. Lots of extra mediocre photos can be overwhelming and you'll never go back to them.

4. **Trends**—As you look at your photos you will also find that you will begin to notice trends to your picture taking. You may see a tendency to only capture certain angles of a subject and you can adjust your shooting. Or maybe you'll notice a thread of an idea beginning to develop as you review a large group of images. I find it really interesting to work with composition by taking some photos, checking how they look, and then seeing what new shots I can make.

5. **More complete coverage**—In the film and video industries there is always a lot of talk about "coverage" (or capturing the subject from different angles, varied distances and so forth). News photographers will do this to be sure they bring back their best photos for their publication. By looking over your photos as you go, you can evaluate your coverage of the subject. This

means you are more likely to get those special images—photos you really want to keep. You won't later be disappointed that you missed a key picture. This will instantly upgrade the quality of your photography.

6. **Pride**—As anyone who takes a lot of photos knows, it can be disappointing when you review photographs from a shooting expedition. Some great photos stand out, but it's normal to find a lot of junk that doesn't quite make it—sometimes seeming to mock your ability as a photographer. When you get rid of bad photos as you go, your mind tends to perceive them as past experiments. When the final selection of photos you bring home are ones that you can take pride in—it's very satisfying.

7. **Less work later**—With a lot of images comes the challenge of editing them down to a reasonable number to work on and keep. This editing job is time-consuming and can mean that photos sit unedited or unused for months. Even if you edit just a little as you go, you make your job much easier later.

8. **Memory cards**—As memory cards get larger and less expensive, space will become less of an issue. Still, cleaning up the trash is a good habit that will optimize the use of your cards.

Tricky situations where the light has strong contrast require you to pay special attention to exposure to get the right tones in your image.

• Exposure

Exposure has become so automatic that it seems like you have to try to get bad results. Cameras and their metering systems really do their job remarkably well. There can be tricky situations—when the light is problematic—when automatic exposure just can't make great photos. Sometimes a "good" automatic exposure from the camera isn't the best exposure for your subject. To get an exposure that truly expresses your intent in photographing a subject—to bring out a mood or to enhance a composition—there are things you can do to transform a good exposure into the great image you really want.

Film vs. Digital

Film and digital capture do respond to light differently. Typically digital cameras act like slide film with highlights (which go blank quickly with overexposure), but respond more like print film for shadows (which hold much detail). So digital cameras are more likely to overexpose highlights than to underexpose shadows.

Hint: Check your camera's metering system to be sure you have an exposure that keeps detail in the highlights and avoids making shadows too bright.

This may mean compromises as the real world often has more detail in the dark and light areas of a scene than the camera is capable of capturing.

When a digital image has washed-out highlights, no amount of work in Photoshop will bring them back. And, although a very dark image may have detail that can be enhanced, it may be lacking in important color information and may show unwanted sensor noise.

from the scene. It is calibrated to give an exposure that will make the scene it sees middle gray—a reasonable choice for many photos.

This simple meter can't really tell if the scene is filled with light, midtone, or dark objects—if the light is the same, the exposure should be identical. But the meter will give different exposures—making light objects too dark and dark objects too light. To compensate, camera manufacturers have developed some rather sophisticated systems for metering that include quite a bit of computing power. These systems usually just work with automatic settings so they cannot be directly compared to metering used with manual exposures.

Typically such a system is based on multiple sensing points across the entire image area. The camera reads the light at these points and then compares them with rather sophisticated algorithms. It does this very smartly, trying to come up with an exposure that works for the range of light values present in a scene. These multi-point systems are called Matrix, Honeycomb, Evaluative, and other names. Each manufacturer's design has its own unique characteristics and strengths.

You have to decide what is most important in your image and expose for it. If the shadows were too bright in this photo, the detail in the smoke at top would be lost.

What is Important?

Are the highlights or shadows most important? Be careful of exposures that give poor data in areas that are important to you. In cases of extreme lighting conditions, expose to get the best detail where it matters most for the success of the photo.

Understanding Meters

It is helpful to understand how metering systems work, from the very basics of the sensor's response to light to how the camera's entire system reads and interprets this information. Many photographers believe that the camera meter is designed to choose the perfect exposure level. Surprise—it isn't! The meter sensor just reads how much light is hitting it

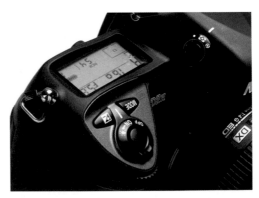

Digital SLRs offer several choices in metering types—the multi-segment systems common for autoexposure work very well.

conditions. Although there will be variations among cameras in different situations, a few generalities can be made.

Exposure Compensation

For most photographic situations the camera's smart metering system offers excellent exposure. Problems occur when the scene is mostly very dark or very light and when a very bright light (like the sun) shines into the lens, especially when it is near an AF focusing point. Once you understand how your meter reacts to light, you can use the exposure compensation feature of your camera to make a quick adjustment and continue to shoot automatically. Exposure compensation is an important tool that allows you to increase or decrease the camera's autoexposure in small steps (usually in 1/3-1/2 stop increments).

Digital SLRs include multiple autoexposure modes. Aperture-Priority, for example, is great for getting maximum depth of field.

Differences among cameras include the number of points available for evaluating an exposure (higher-end cameras typically have more), and the proprietary algorithms used by the camera itself to process exposure information. In the last few years distance has been added to the equation—providing information about where the lens is focused. Now every manufacturer will tell you their meter is best but actually, these systems all work very well in most

Autoexposure Modes

Every SLR on the market offers multiple autoexposure modes that use the complete metering system to give you a good exposure (manual metering does not use all parts of the camera's exposure computations). These modes feature approaches to exposure that meet varied needs of photographers. They are interchangeable, since they all use the complete metering system of the camera to calculate equal exposures for the scene, but they are different in that they offer varied interpretations of shutter speed and f/stop.

Exposure compensation, +/–, is an important tool on your camera. It allows you to adjust the autoexposure to make it right for your subject.

Digital SLRs have three autoexposure modes—Program, Aperture-Priority, and Shutter-Priority—plus full Manual exposure control. On this camera, these modes are represented, in order, by P, A, S, and M.

Not all scenes have the average range of tones that meters like. With bright scenes like this, the camera will often underexpose it, so you need to compensate with added exposure.

The Three Autoexposure Modes

- **Program (P)**—The camera sets both the aperture and shutter speed for you.

- **Shutter-Priority (S or Tv)**—You select the shutter speed and the camera sets the aperture for you. This allows you to control how action is rendered in the photograph.

- **Aperture-Priority (A or Av)** —You set the aperture (lens opening) and the camera chooses the shutter speed. This gives you control over depth of field.

Meters Like Average Scenes

Remember that meters are designed to set exposure to make the overall scene middle gray or mid-toned. If nearly everything in the scene is very dark or very light, the camera's exposure system has no reference and it will default to the old mid-tones. Dark scenes will be washed out and light scenes will be dark and muddy.

So for scenes that are not average, decrease your exposure compensation (– values) for dark subjects to reduce the metering system's tendency to add light and increase your exposure compensation (+ values) for light scenes to adjust for the meter's over-reaction to bright subjects.

Even if your camera features all these autoexposure modes, you don't have to use them all. You want to use a mode that you feel comfortable with. You may find a particular mode works for you—one that feels just perfect. Choose it!

Program Mode (P)

Even though the camera is making the basic decisions, the standard Program mode can be adjusted. You can usually shift the shutter speed or aperture slightly and the camera will adjust. Plus, you can use exposure compensation as needed. This is a mode for a photographer who

Program mode is a great choice for shooting quickly, such as this grab shot of a Japanese student on a field trip, and exposure compensation can be used as needed.

needs to shoot varied scenes quickly—without a lot of thought. The camera will choose reasonable combinations of shutter speed and aperture for the conditions. Street and travel photographers sometimes find it useful as it works without much attention from the photographer.

Shutter-Priority Mode (S or Tv)

Shutter-Priority is an important mode when you must have a specific shutter speed for rendering movement, or when you want to get the maximum depth of field possible at a handheld shutter speed. The latter may seem a little odd since f/stops control depth of field not shutter speed; but it works! You may find that for a certain lens you need to shoot at 1/125 second when handholding the camera. If you use Program or Aperture-Priority, you'll never know from shot to shot if you'll have that shutter speed. If you choose a high shutter speed, f/stops will be wider, so depth of field will be lower. When you are handholding and know that

When you need a specific shutter speed, such as a slow speed to blur action, then Shutter-Priority autoexposure is an excellent choice.

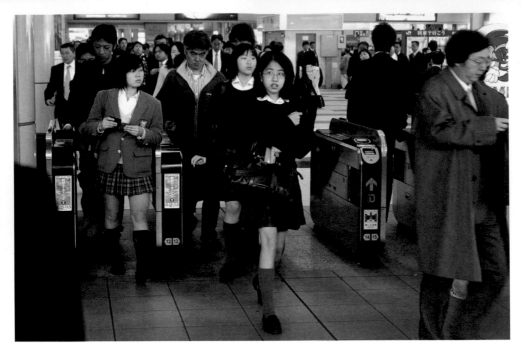

To get the most depth of field in a shot, you need to choose a small f/stop. The best exposure mode to use in this situation is Aperture–Priority mode.

1/125 works well, if you then use S or Tv, the camera will always set the smallest f/stop for that shutter speed and you always get the best depth of field possible.

Aperture-Priority Mode (A or Av)

In Aperture-Priority mode, you can select an aperture for specific depth-of-field effects (from deep to shallow) and gain the right shutter speed automatically. You can also guarantee the fastest shutter speeds possible, which is one reason why many pros (and especially sports shooters) like this mode. The fast shutter speed with A or Av seems a bit counter-intuitive. This is how it works: When you set a wide lens opening for the lens, the camera will always need to choose a high shutter speed to compensate. (Of course "high" is relative since lighting conditions affect actual exposure). Choose the widest opening (the smallest number for the lens) and the camera must choose the fastest shutter speed possible

for the conditions. By leaving the lens on this f/stop, you guarantee the highest possible action-stopping speed.

Automatic Exposure Bracketing (AEB)

Automatic exposure bracketing (AEB) is offered on almost all cameras. It is a useful function whenever exposure is critical and/or subject contrast is unusual. This feature can be used with Program, Shutter-Priority, and Aperture-Priority modes. The camera's exposure bracketing system automatically changes exposures over a series of three photos, which deviate by a set range from the metered value. You can usually control these settings in the camera's Custom Functions menu.

Full Auto & Picture Control Modes

Many cameras offer a totally automatic, sometimes called Green, mode that does not allow you to change anything. This is a great mode when you let someone else

Auto exposure bracketing is a convenient way to ensure that your camera gets the best exposure for a particular subject. Once set, it automatically takes three exposures: one lighter than the meter reading (top photo); another at the meter reading (middle photo); and one darker (bottom). You can then choose later which is best for color and tonality.

use your camera. It isn't very useful for the thinking photographer, because it often doesn't allow exposure compensation.

Also, most cameras include special modes sometimes called Picture Control or Subject modes, which are additional auto-exposure modes that favor certain subjects or ways of taking pictures. These are designed to work with specific subjects such as Portraits, Landscapes, etc. On some digital cameras they also affect more than exposure such as flash, focus, and focal length.

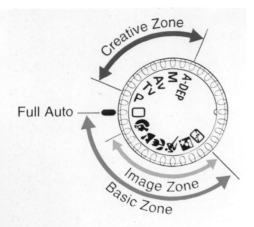

Full Auto

Creative Zone

Image Zone

Basic Zone

Many cameras include multiple types of exposure modes. In this camera, the Basic Zone includes several picture control modes that allow you to tell the camera what type of picture you are taking. The camera does the rest of the thinking for you. On the other hand, when using the Creative Zone, which houses user controlled autoexposure modes like Aperture-Priority and Shutter-Priority, you are free to choose the settings according to the situation.

Common Picture Control Modes

- **Portrait**—This mode favors wide apertures, for shallow depth of field that accentuates the subject.

- **Landscape**—Designed for scenic photography, this mode favors small apertures for maximum depth of field.

- **Action or Sports**—In this mode, high shutter speeds are favored to stop action.

- **Night**—This mode is helpful for long exposures without flash.

- **Night Flash**—This mode balances flash with the background exposure.

- **Close-Up**—This mode sets the best aperture and shutter speed for close focus work.

Manual Exposure

Manual exposure is still important but, to make the most of it, you really need to spend some time experimenting so that you understand how it works—especially since it does not include the sophisticated calculation involved in the multi-point autoexposure systems. Thanks to digital technology you can learn some of the basics very quickly since you can see the results instantly.

Manual exposure can be helpful in dealing with extreme contrasts of light. It will let you limit exposure in relation to specific tones of light in a photograph.

Why Use Manual Exposure?

Manual exposure is especially useful when you have tricky lighting conditions or when shooting panoramic photos where side-by-side photos are taken and must match so they can be built into a panoramic in the computer. Manual exposure is also useful for problem flash exposures, when you are trying to match flash with existing light.

A good example of this is when you're shooting indoors near windows. The light on the subject doesn't change, but—as you move around—the brightness of the background can change (e.g. as you move to include wall or window). Although exposure should remain constant on the subject, autoexposure will usually fail to do that in these lighting conditions.

White that holds detail, such as the feathers on this egret, can be a real challenge for a meter. Manual exposure can help by allowing you to set a specific exposure based on that white detail.

Autoexposure will frequently change the exposure as these multiple images are shot, creating problems when you try to put them together later. Manual exposure lets you set exposure that will not change from image to image.

Flash that balances the ambient light can be a very effective technique that takes away some of the harshness of direct flash and makes it look more natural. In Manual (or M) mode you freely choose both shutter speed and aperture. The aperture affects the brightness of the flash and the addition of shutter speed controls the brightness of the ambient light. The digital camera lets you experiment and immediately see what you can get by making these adjustments.

Most cameras today offer several metering system options for Manual mode, like center-weighted and spot-metering. These are

sometimes available for other modes. (There is no standard, so check your camera's manual.)

Center-weighted systems favor the meter sensors in the center of the photo, then decrease in sensitivity toward the outside of the frame. It is probably the manual exposure system most commonly found in cameras. You can take advantage of this by setting an exposure and pointing your camera to center on the key light of the scene. Then recompose so that it is no longer in the middle.

Spot metering is another useful manual exposure metering technology where a tiny spot in the image area is used for checking exposure. True spot metering is the ability to meter a "spot" that is just a few percentage points of a scene. This is not very common in cameras. Most digital SLRs use something called partial metering, where the metering is centered in a small area of the center of the viewfinder (often about 8-10%). If you use a telephoto focal length, this becomes a true spot meter.

Spot metering is ideal when you have problems getting a reading off a subject where the surrounding areas have varied lighting. (Manual exposure is especially useful during a theatrical show with spotlights.) Metering the overall scene would give an exposure that's over-influenced by the darkness around the lights. A spot meter reading could zero right in on the key parts of the scene in the spot light. Since the metering area is so restricted, spot metering does take practice to use effectively.

With spot metering, it is critical to remember that the meter is designed to make whatever it sees into a middle toned exposure. This is where beginners can get into trouble. Since the area metered is so small, the camera takes the reading as is—without interpretation. So if the spot is bright white or deep black, the meter will try to make it

middle gray, giving too little or too much exposure, respectively. Spot metering can be used quite effectively if you meter something middle gray in tone, such as a gray card, or you learn how to interpret its readings of bright or dark things.

Beyond "Good" Exposure

Since automatic metering systems are so good today, the big issue for the photographer becomes not just getting a "good" exposure, but how to get the best exposure for the subject and scene. This can be extremely subjective, depending on a subject's colors, textures, and tones. Some photographers want to stick to arbitrary "rules" of exposure, because they aren't confident of their ability to subjectively judge an image.

Let's look at what the best exposure might be for a digital SLR.

- **First:** It should be one that gives you the best image-data for your purpose. If you want to make a great print, you need to have the appropriate exposure data for highlights and shadows that can be edited in the computer. If you want to make a print directly from camera to printer, you need to know what bias the printer has (e.g., it makes prints lighter or darker than the version on the LCD). If you are a pro, you need to confirm that production systems react to exposure the way you and your camera do.

- **Second:** Consider the requirements of the subject. A big mistake made by many amateurs is accepting the existing exposure for the scene without thinking about what that exposure does to the subject in terms of rendering it realistically or creatively. A dramatic but dark mountain might look weak and washed out with

The best exposure is highly dependent on your subject and the light. Use the histogram to gather the image data needed for your final purpose.

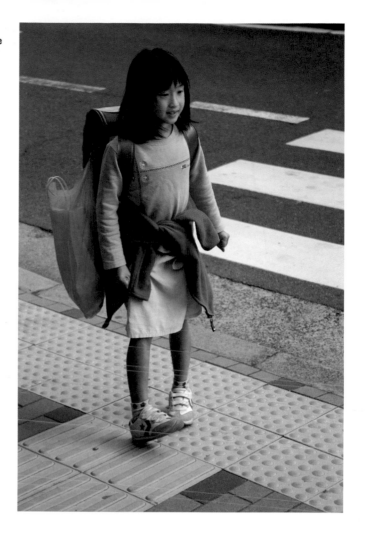

basic exposure because the dark areas are just too light. Similarly a bright beach might look dim and less than sunny with a basic meter reading. You need to interpret your exposures, and here again, the LCD comes through with a techno-logical advantage.

Using the LCD & Histogram

As I've stated many times, one of the truly great advantages of digital cameras is their ability to let you review exposure on the LCD. You can see the image right after

you've shot the photo (if the camera is set for Review display) and determine what the highlights and shadows look like.

So, what can the LCD do for you? It can quickly tell you if a scene is so contrasty that you cannot capture all the detail there. It will show you if the subject has been captured appropriately: Are the dark trees dark and white buildings bright? It will give you ideas to change exposure to match the needs of the scene. It helps you decide if the photograph is going the way you want it to. If you enlarge the image, you can usually see if needed detail exists in highlights or shadows.

There will be situations when the little LCD monitor isn't as good as you'd like for evaluating exposure. That's when the histogram is used. The histogram is a graph that tells you about the exposure levels in your shot. For the best evaluation of exposure, cycle your display to the histogram. Every digital SLR has this ability—check your manual for details. For film photographers, the histogram's techy graph-look can initially be confusing or even intimidating. My suggestion is: Try it! With a little practice the histogram is actually fairly easy to understand. You really don't need to know any math to read it. At its basic level it is simply a graph of the number of pixels with specific brightness values from dark (on the left) to bright (on the right).

How to Interpret What You See

The key to reading the histogram is to see what is happening at the left and right sides of the graph. An exposure of an average scene that gives good image data will show a histogram with the graph above the bottom line from left to right, without an imbalance of brightness values on one side or the other. Understand that this is true for a scene that has a full range of brightness. Not every scene will have values that balance completely from left to right. Dark or bright scenes will favor one side or the other.

One thing is critical: The range of tones for important brightness areas of a photograph should finish before the end of the graph at one side or the other. In other words, they should not be abruptly cut-off at either side—detail is important there. Whenever the histogram stops like a cliff instead of a slope at the sides, it means the exposure is "clipping" detail.

This is where you can run into trouble with your exposure. Any values to the right of a clipped right side are gone, washed out, and overexposed without detail. If they weren't captured at this point, you

never get them back. Some cameras will display an overexposure alert in the image itself by blinking the tones in these areas. Any values to the left of a chopped left side are also gone without detail. They can only be seen as black, as no data has been captured for them. If detail is important for dark (left) or bright (right) parts of the photo, you need to adjust exposure to bring the slope of the histogram back into the graph.

How the detail in the histogram is arranged can also help you evaluate your exposure. If you're photographing a bright scene, the histogram should show most of the values to the right—where bright values should be in a histogram. Since bright subjects can be easily underexposed, those values may sit to the left half of the histogram. This is the wrong place for them, which may mean problems for you when adjusting the image later in the computer. For dark scenes the story is similar. These tend to be metered with too much exposure and may sit too much on the right side of the graph—the bright side—instead of where they belong—at the left. The graphed values should reflect the scene. So a bright scene should have much of the graph on the bright, right side, while a dark scene should have the graph favoring the left.

A great benefit of the LCD monitor and the histogram is that you can shoot on automatic and use all the computing power and advanced metering systems that you paid for. All you have to do is check exposures on occasion and you never have to be surprised by exposure problems again.

• Long Digital Exposures

Very long exposures have been a challenge for digital cameras. You might want to try moonlit landscapes, star trails, or other interesting images under night conditions. However, as your times increase into the

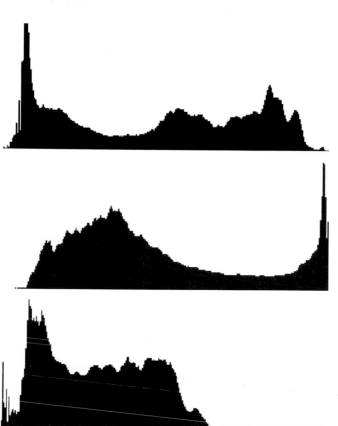

This is a balanced histogram. The detail in the shadowed parts of the photo (left side) shows up quickly in the graph, and the white detail (right side) stays within bounds. A sharp cut-off of the slope at either side means you are losing detail in the dark or bright parts of your image.

In this histogram, the whites at right are "clipped," meaning the data drops off at the edge of the graph. The blacks are weak, so this would be an overexposed photo.

This histogram has no whites (the right side has no data). Even if this were a dark image, the exposure as seen here would likely lead to a noisier image than needed because the dark areas would have to be lightened so much.

minutes range, you will find that the image deteriorates in most digital SLRs. This should change in the future.

You might see a severe increase in noise and odd picture anomalies such as bright white circles at the edges of the frame. They occur when sensor amplifiers—positioned near the edge of the frame—heat up and affect sensor performance. On some older camera designs this can start happening at around 60 to 90 seconds.

The long-exposure noise reduction function on most digital SLRs will help produce great results up to about 30 seconds—the longest timed shutter speed on most of these cameras. To go longer you need to use the Bulb setting and hold the shutter release down for the time desired.

Good results at longer exposure times up to about 3-4 minutes are possible, but not antic-ipated by the camera manufacturers. In longer exposures, you will often see those odd bright circles along the edges of the image. Currently even the cameras with the most recent technology will often exhibit light areas near the edge of the frame with exposure times exceeding 3-4 minutes. The only thing you can do is keep your exposure times to 60 seconds or less and use the camera's long exposure noise reduction setting.

• Combining Exposures

A great challenge for photographers is capturing the range of tones we can see—versus the fewer tones that film or a sensor can handle. This has always been a major limitation of the technology of photography. Many, many dramatic photographs of scenes with bright sunlit mountains and black, shadowed trees look nothing like the real scene that appeared before the photog-

Combining exposures: This image becomes truer to the actual scene than the camera captures from a single exposure. It uses two different exposures (right) to create a single image.

rapher's eyes. Compared to what our eyes and brain can process, the ability of most films and digital cameras to capture everything in such a scene is extremely limited.

To deal with this problem, Ansel Adams developed the Zone System. He would expose for specific parts of a scene and then develop the film and control the print in order to translate that exposure into the tones of a photograph. Unfortunately we do not have that control with color-film development and printing—one reason Adams did comparatively little color in his personal work.

A truly elegant way of handling extreme tonal range is with a double-exposure technique that is absolutely ideal for digital cameras. You make one exposure that is optimized for the bright areas and a second exposure for the shadows. You then combine the two shots in a final image in the computer, using the good exposure of bright areas from one photo and the good exposure of shadows from the other. It is even possible to combine

more than two exposures for big variations in tones in a scene. Still, the basic technique is the same.

How to Combine Two Exposures

1. Put your camera on a tripod and take all exposures with the same composition and framing. (Handheld shots will be hard to match.)

2. Meter the bright and dark areas. Write down these exposures because once you start the next steps, you cannot reposition the camera.

3. Make an exposure based on the bright areas.

4. Without moving the camera, make a second exposure based on the dark areas.

Here is where a digital camera really shines! As long as you were careful not to adjust the camera, both photos will line up exactly. There is no film to slightly

These are two photos straight from the camera; the darker image was exposed for the bright sky, the bottom to get more detail in the shadows. When combined in the computer (see photo on page 80), you effectively increase exposure range.

shift position in the camera or scanner to make lining up difficult later. The worst that usually happens is a slight movement of the camera as you change exposure. A good way to avoid that is to shoot with auto exposure bracketing (AEB). Then the camera changes the exposure for you automatically as you

This is another example of combining two exposures. The lower exposure did have a graduated filter to balance the top a little, but a separate exposure for the sunset did even more.

shoot three photos—one at the meter reading and two variations in exposure (usually above and below the meter's choice for proper exposure).

Using a layers-based program, you will make basic adjustments to the pair of photos (correcting blacks, etc.). Then line up the two photos together (one on top of the other) in separate layers. You can then remove the bad parts of the top image, letting the good parts in the lower image show through. I like to put the shadow exposure on top of the highlight exposure. Then I take out the washed-out highlights of the shadow exposure, which will let the good highlight exposures show through from below. If your program includes it, a layer mask will give a lot of control over the removal process. You will even be able to bring back things that you took out by mistake. You can also use the eraser tool or you can select the bad areas and delete them.

Next fix the edges between the two photos. This is where the craft of technique is so important. With practice you can make edges blend quite nicely. Try using soft brushes in your layer mask. Soft eraser tools on programs without a layer mask can help, although they often require a lot of "doing and undoing" to get it right. Adjust the opacity/transparency of the top layer until the detail looks right to you.

The bottom line is that this double-exposure technique works and it delivers an image of the real world that you can control without being limited by film technology. It is especially fun with digital cameras, as they make the technique work so well. You gain a wonderful color and tonal range that can be closer to what your eye actually saw in the scene. How bright the shadows should be is very subjective, so just make your final adjustments based on what is appealing to you, as well as what you want to communicate about the scene.

white balance

White balance control options give you multiple excellent choices that are usually better than using Auto white balance.

While it is a totally new control for most photographers, white balance is an important tool to understand and use. I believe it is such a key tool of a digital SLR that it is vital that you get to know it. It is both a corrective and creative tool of value to every photographer. While it does add complexity to taking pictures, it really does not take long to learn how to use it well. Once you see the benefits of white balance, you will be glad that you have mastered its use.

• The Color of Light

To understand white balance you need to know a little about the color of light. Our eye-brain connection makes most normal light look neutral so that colors stay consistent. A white will look white to us—whether it is in the shade, in the sun, or indoors under fluorescent lights. Yet those three lighting types have very different color temperatures. So with most sensitive recording devices (film, video camcorders, digital cameras), the lights will render colors differently. This is why people's hair often looks green when photographed with film under fluorescent lights.

The Cloudy white balance setting helped warm up this close-up shot on a cloudy, sometimes rainy, day.

Low early morning light is warm, but Auto white balance will often remove that desirable color cast. In this case, the Flash white balance setting was used.

Photographed in the shade, open to the blue sky, this could be a very cold looking image if not shot with the appropriate white balance setting. Cloudy was used here.

Without getting deeply into physics, here's the gist: Color temperature is a standard that measures the color of light based on how a theoretical black body emits light when heated. It is expressed in Kelvin (or K)—a basic unit of thermodynamic measurement. (Technically it has no "degrees," but you will often see it expressed as degrees K, or °K.) It is the reverse of our weather temperatures, where high = hot and low = cold. In the Kelvin system, low numbers such as 3,000K are warmer and high numbers like 10,000K are colder.

Incandescent lights tend to be between 2000-3800K, while sunlight at noon is near 5000K and light from the open sky at 10,000K or higher. With daylight film, the noon sunlight would appear neutral, and the open sky light would be bluish. Fluorescent lights are a little different since they have what is called an incomplete spectrum, so any K temperature for them is a bit of a compromise. Depending on the type of fluorescent, the light that film and sensors see is somewhere between incandescent and sunlight.

White balance settings actually affect the colors within your photo. These same flowers look different depending on the setting used. You need to experiment a bit to learn how your camera's white balance settings affect images.

How the Camera Adjusts Color Temperatures

To achieve white balance control, the camera looks at the white and neutral colors of a scene—either automatically or with your help—and makes them neutral in that light (regardless of the source and its K temperature). It usually makes the scene appear more like what it does to the eye than film does.

It is obviously a corrective tool in that you can be sure the colors are right for a scene (such as making whites look correct regardless of light, whether fluorescent indoors or sun at midday). But it can go too far, making the warm light of a sunset, for example, technically "correct" yet lacking the warmth we expect in a photograph of a sunset.

White balance is also a creative tool. You can change the response of the camera so that the light is warmer or cooler than the camera wants to set it based on its "agenda" of making all light neutral. In this way you can have a sunset photograph that looks more like you expect sunsets to look. Also, you can adjust the color of a scene, so that it gives you more

than you might expect—making a friendly family scene look warm or a cold winter day even look colder.

It is true that you can make color adjustments in the computer, and with RAW images you can totally change white balance after the fact. There are some very significant reasons not to do that, however.

Why You Should Adjust as You Shoot

1. **Better craft**—Photography is a craft. Paying attention to details such as exposure, action-stopping shutter speed, depth of field, and focal length, is part of the process that enriches the photo and the photo experience. White balance selection is a new part of that process.

2. **Connection with the scene**—If you do adjustments later in the computer, you are no longer at your location, so any adjustments have less immediate connection with what is "right" (either objectively or creatively) for the scene.

3. **Higher quality**—Adjustments made later, in the computer, have the potential of affecting the actual pixels in the photo and reducing image quality.

4. **Better review photos**—If the white balance is good you are evaluating photos on the LCD for composition and exposure—without being distracted by off-color casts.

5. **Less work**—A photo that has the proper white balance from the start requires less work later. Even with RAW files this is an advantage, as you won't need to agonize over what is right.

Caution: RAW files require such a large degree of adjustment that the range of choices can sometimes be overwhelming and even counter-productive.

• What is White Balance?

While new to still photographers, white balance has long been a key part of video. With the arrival of the portable color news camera in the 1970s, videographers began white balancing their images. These video shooters had no automatic white balance and had to point their camera at something white and tell the camera to make that white a neutral white—with no color cast to it.

White balance on digital cameras today is far more sophisticated, but works on the same principle—making whites and other neutral colors neutral without color cast. When photographers first start shooting with a digital camera, they often have no idea that they can change white balance settings. To be fair, until recently, many manufacturers buried white balance. Most digital SLRs now have white balance labeled on a body control. I believe cameras should allow you to get to it from a single button push, but some require a bit of juggling with dials and buttons. It is definitely worth the effort! In fact, white balance is as important as exposure controls if you want to get the most from your digital photography.

Automatic White Balance

Automatic white balance is useful for shooting quickly in changing light conditions. However, I do not select auto as my standard. I only choose it when it is appropriate—it becomes simply another choice in the white balance menu. I don't find the auto setting consistently gets the results I expect. Two very good examples are the conditions at sunrise and sunset. We are used to photographing them with daylight-balanced film, which makes them warmer than what we actually see with the eye. For years nature photographers have shot

Automatic white balance is okay, but using a specific preset can give you more control. In this photo, the Flash setting was used to warm up the scene slightly.

them with Fujifilm's Velvia—a film that results in more intense colors. If you shoot with auto white balance, the camera will usually try to remove some of that warm color, as it doesn't know what you expect from the scene. It just sees what seems to be a lot of very warm light that needs to be corrected. In this instance, you are better off choosing a preset.

All digital SLRs come with preset white balance settings. These are very useful because you can try to match the conditions to the preset's name—sun, shade, fluorescent, etc. This is especially useful if you are traveling and need to take a photo indoors under fluorescent lights. Using the fluorescent setting, the colors will clean up quite well. Some cameras come with different sets of presets, even including multiple fluorescent choices.

The first critical issue in choosing what white balance setting to use is to consider

matching the preset to the light it was designed to measure. This does several important things for the photographer:

1. Colors look natural.

2. Neutral tones stay neutral (or at least reasonably neutral).

3. Photos keep consistent in a given lighting condition.

With a preset in a specific lighting condition, all photos will have the same color balance and do not change color from shot to shot. When shooting automatic, you can get variation in color as the camera tries to compensate for different things it sees through the lens, even though the light has not changed. It can be very frustrating to cope with varied looks to photographs taken in the same light when that variation is due to the unpredictability of auto white balance.

Camera designers seem to enjoy finding new places to put white balance controls—there is no consistency among the various models. You have to check your manual.

Common White Balance Presets

Daylight—This setting (usually represented by a little sun) is designed to make your camera see colors in a way that is normal when the light is from the sun in the middle of the day. Light that is warmer (lower K temperature) or bluer (higher K temperature) than daylight will photograph as warmer, or bluer, even though your eyes will adapt to different conditions so that the colors look neutral to you. It is only when the subject is actually in the "balanced" light that neutral colors will be truly neutral. Daylight white balance acts like a daylight-balanced film.

Shade and Clouds—Most white balance settings are really pretty descriptive, such as these two, which are balanced for the bluer light (higher K temperature) typical of the light from open shade (shade open to the sky) and cloudy days. The Shade control usually has a symbol like the shade of a house, while the Clouds icon looks like, well, clouds. Under those conditions, the camera will remove the blue cast (open shade is usually slightly stronger in its blue removal effect) and make photos look better (with more natural colors). These settings also mean that daylight itself looks warmer (it is like shooting with a warming filter) and indoors (with low K temps) will be very warm.

Incandescent or Tungsten—This preset is designed for indoor lights and studio quartz lighting. It is really a wonderful opportunity for the digital photographer to gain more natural indoor colors than was typical of film (indoor lighting needed special film and/or correction filters to balance the colors). The Incandescent, or Tungsten, preset makes colors look closer to the way our eyes see them under these conditions. It balances to a light usually close to 3200K (the color temperature of quartz lights). While making indoor lighting look more natural, this setting will also make the outdoors look very cold.

Fluorescent—One of the great frustrations of photographers was trying to get good color shooting film under fluorescent lights since they are so varied and do not have a full spectrum of colors. Even the digital camera's white balance can have trouble with them, but, much of the time, it will work great and remove the ugly color casts that were so common in these lights when using film. Due to the variability of the lights, many of the pro cameras have multiple fluorescent settings, which gives the photographer more opportunity to get good color. They do render strange effects if used under other lights, but can they offer an interesting richness to sunrise and sunset.

Flash is another option on most cameras. Electronic flash is usually a little cooler than daylight in color temperature. It can be too blue for a lot of subjects, so this setting warms it up and also creates a slight warming tone to daylight images.

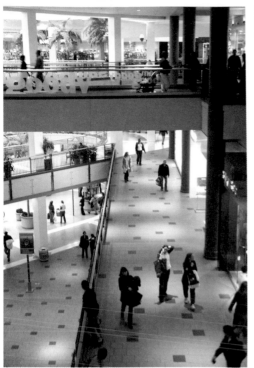

You can see how the colors of light change within the scene itself in these photos. In such mixed conditions, you need to experiment to find the best white balance for your needs.
Top left: Auto. Top right: Fluorescent. Bottom left: Daylight. Bottom right: Cloudy.

Getting the Most from the Presets

To get the most from white balance, you need to think beyond the preset's specific name. Using the electronic flash white balance setting for most outdoor photos is like adding a warming filter to the scene—an effect I like. Unfortunately, there are no precise "standard" specs or definitions of manufacturers' preset white balance settings, so this may or may not work for you. You may find that your camera does a nicer job using shade or cloudy settings.

I believe that it is really worth experimenting with white balance settings. Try the different preset settings on the same subject to see what they do and think how you might use them beyond their specific names. The really neat thing about doing experiments like this with a digital camera is that you "waste" no film—and you don't even have to take notes!

The picture's metadata (see page 92) will tell you nifty things like the white balance in use. Your "info" button on the camera will usually tell you this and you can read metadata in many browser and image processing programs.

Although you can't completely evaluate the effects of these settings until you download the images to your computer, your camera's LCD can help you judge the different settings on a particular scene. It is true that the little monitor on the camera isn't that accurate for judging all colors, but—once you see the same images on your computer and compare them to the LCD view—you'll be able to better interpret what is on the camera's LCD.

Custom or Manual White Balance

Another level of white balance control is the custom (or manual) setting. Custom settings can be very helpful when you need to precisely match a given lighting condition. The camera will actually help you pick an exact white balance for the light colors, which become very natural—with no color casts from the light.

To do this, point your camera at something white, or gray, (it does not have to be in focus) and follow the procedure for color balancing. The camera analyzes that specific white and adjusts the color so that the white (or gray) is neutral in tone. There are a number of ways cameras accomplish custom white balance. This also varies with brands. Check your camera's manual.

This technique is useful for a variety of purposes. One is simply to deal with unique lighting situations (more common indoors) when you need to get a neutral light. This can give quite remarkable results in tough situations with industrial fluorescents. (It can't make yellow sodium vapor lights and similar lights neutral, since those lights only have a limited range of color). The camera will make the white or gray card as neutral as possible so you can shoot without filters and get results close to what the eye sees.

You can also use custom settings creatively by color balancing on something that isn't white or gray. You use a paper with a pale color on it and the camera will remove that color and make the paper gray. This will make the photo look like you shot it through a filter of a color opposite to the pale color you used for "balancing." A good example of this is using a light blue card for white balancing. The camera warms up the photo because blue is removed. With the right blue you can get some very pleasing warm tones when photographing people's faces. You can try all

You can see by the variation in these images that the creative use of white balance offers photographers many possibilities for color. The only change was white balance.

sorts of colors for a whole range of interesting effects. For example, color balancing on a pale red-magenta paint chip would be like having a green enhancing filter, because overall, greens will be boosted.

An Instant Enhancing Filter

Creative use of white balance works just like an enhancing filter. But it enhances everything in the photo—so be careful.

RAW & White Balance

Finally, shooting in RAW influences color balance choices. RAW files give you the ability to go back and change your original white balance choice. This does help compensate for automatic inconsistencies, as you have a color coming into the computer that is at least close to what you want. This means a lot less work and much more con-

sistency with multiple images. However, this should never be an excuse for not setting white balance as best you can.

White Balance & Exposure

White balance has little effect on exposure but, because it is altering the camera's response to colors, a slight effect can occur. Test and know your own gear. White balance is also used with Picture Control or subject modes on many cameras (e.g., a camera chooses a Cloudy white balance setting for a Sunrise/Sunset mode). Specific modes use a number of factors available in the camera for the settings, so general comments are difficult. You have to try them and see what you like. Sometimes the manual will tell you what is being used. Sometimes you may not agree with the manual. Fine! Do what works best for you.

Filename	IMG_9224.JPG
Date Created	1/1/1980 12:00:00 AM
Date Modified	7/30/2003 06:35:54 PM
Image Format	JPEG
Width	2272
Height	1704
Color Mode	RGB
File Size	1.47M
Make	Canon
Model	Canon PowerShot G3
Orientation	Normal
X Resolution	180.0
Y Resolution	180.0
Resolution Unit	Inches
Date Time	2003:07:30 18:35:56
yCbCr Positioning	Centered
Exposure Time	1/200 sec
F-Stop	4.5
ExifVersion	0220
Date Time Original	2003:07:30 18:35:56
Date Time Digitized	2003:07:30 18:35:56

With metadata, you no longer have to write down key parts of your photography. Things like exposure, white balance, and more are recorded with your image. Most image editing programs allow you to access this information in the computer.

• About Metadata

A great way of learning about photography is to shoot a lot of experiments and record your settings so that you can compare it to the results later. But actually doing that is tedious. With a digital camera, that's all changed. The camera does it for you.

A lot of information about every photo you take with a digital camera is automatically recorded. This is called metadata ("data about data") because it is information about the data that makes up an image file. You'll also hear about EXIF data—that is a specific set of metadata.

How Can You Use This Information?

You can find such things as shutter speed, f/stop, focal length, white balance, ISO setting, flash usage, and much more. There is also information that is useful mainly to computer engineers. But the basic photographic parameters are there and ready for your use. You can access metadata in several ways. On most digital SLRs, when you change the display to read a histogram, you'll see some key information about exposure—shutter speed, aperture, and ISO—immediately. The Info button will also give you this information, and more.

• Computer Access

In the computer, many programs can access metadata. Adobe Photoshop and Photoshop Elements include it in the browser function. Browsers such as ACDSee from ACDSystems and MediaPro from iView will display it, and most RAW conversion software will show it as well. In addition, browser programs often let you make index prints that include data like shutter speed and f-stop with the photo. The excellent Windows XP Explorer replacement, Directory OPUS (www.gpsoft.com.au), includes easy access to this information. Programs vary as to how much metadata is included and its arrangement, but they all include the key photographic information.

memory cards &
digital workflow

Memory cards are sometimes referred to as "digital film" and come in a variety of forms, each dictated by the type of camera the card is used in.

Memory cards are sometimes called "digital film," since they record images and can be removed from a camera like traditional film. There is a difference, however, since film is light sensitive, therefore acting like the sensor and memory card combined.

Still, thinking of a memory card as digital film is helpful, since it is a way to remove images from your camera and take them for processing to produce prints. It is worth knowing a little about memory cards in order to get the most from them.

• Types of
Memory Cards

Memory cards come in a variety of sizes and shapes and the different types are not interchangeable. Almost all memory cards use solid-state memory—there are no moving parts. The only exception to this is

the Hitachi Microdrive (formerly IBM), based on a miniature hard drive. Most digital SLRs use CompactFlash (or CF) cards. They are solid, reliable, memory cards about the size of a matchbook and come in two versions—Type 1 and Type 2. Most digital SLRs accept both. There is little that can damage them. If you drop one in the mud or sand, clean it and plug it back in. I have even run them through the wash with no ill effect, though heat from the

Choosing Memory Cards

- There is no quality issue that applies to card size. Buy and use whatever works for you and be confident you are doing the right thing.

- Large cards are very convenient when you must shoot a lot of images at one time.

- Wet conditions make larger cards extremely helpful since you can keep the camera closed as you shoot because you don't have to replace cards as often.

- Having multiple cards gives you some added security. You can keep filled cards in a place separate from your camera.

- Multiple cards always give you back-up flexibility.

- Multiple cards give you options in shooting. A pro might separate parts of a shoot by putting them on different cards.

dryer can damage them. The card begins to fail only if the plastic casing is chipped or cracked.

Microdrives look like a CF card of the thicker, Type 2 model, but they are a different type of device. They will replace CF cards in most cameras (although some older cameras do not recognize them). They offer increased storage at lower prices, but they are also much more sensitive to damage than CF cards. Since they have little spinning drives inside, they can be damaged if dropped and water will ruin them. I would not recommend them for photography where the card has to be changed frequently, increasing the possibility of damage.

Many small digital cameras use SD and xD cards. These are much smaller than CF cards and thus allow cameras to be made more compactly—although this is less of an issue with digital SLRs. Since the CF card is so entrenched, there is the misconception that it is the more "professional" card. That isn't true. CF cards just came first. SD and xD cards are newer technology and offer faster speeds, even better than the best of CF cards today.

You have no choice in the type of card your camera can use. Nearly all require different mounting mechanisms and circuitry on-board the camera—a few offer dual card systems.

• Speed

The speed of a card is misleading. Memory card manufacturers promote higher and higher card speeds. This is essentially how fast the card can write data to memory. You'll see all sorts of speed references. Still each speed noted with CF cards simply refers back to the original card speed (which was 1x). Even the fastest CF cards with the highest speed specs are slower than SD and xD cards.

Is a 16x card is faster than a 4x card? Yes. Is it four times faster in your camera? No, it is probably only slightly faster.

Here are some things to consider about write speeds

1. **Data recording only**—Card speed affects how fast the card records images, but does not affect things within the camera itself regarding speed.

 Note: Card speed does not directly affect how fast a camera can take pictures—only how fast image data can be recorded to a card.

2. **Camera speed**—The speed at which a camera can process and move data through its system effects how quickly it can put an image file onto a memory card. If the camera is slower than the card, no amount of increased speed on the card's part will influence how fast the card can actually work.

3. **Buffer capability**—One thing that significantly affects the speed of a camera is its buffer, or the in-camera memory. It stores image data as it comes from the sensor/processor and before it goes to the memory card. A large buffer with a fast connection to the rest of the camera will let the camera work as fast as possible. A fast memory card will remove data from the buffer faster so the buffer is ready to accept pictures sooner.

4. **Continuous shooting**—Card speed, buffer size, and camera speed all have a major affect on the camera's continuous shooting ability.

How to Approximate Card Capacity

Card size	High-quality JPEG	RAW photos
128 MB	42 photos	12 photos
256 MB	85 photos	25 photos
512 MB	170 photos	50 photos
1 GB	333 photos	100 photos
2 GB	666 photos	200 photos
4 GB	1,333 photos	400 photos

The main thing that a fast memory card affects is shooting speed—how many photographs you can shoot at any one time before the camera has to stop and wait for its buffer to clear. If you rarely shoot a great many photos at one time, then a fast card will have little effect on your photography. On the other hand, if you need to shoot sports action that goes continuously, every bit of card speed you can get will help.

• Memory Size

It is good news that memory cards today are relatively inexpensive. It wasn't too many years ago that a 64 MB card cost many hundreds of dollars. That size card is now considered very small and won't hold many images. So what size do you need?

It depends on how you like to shoot. Consider this: For a six-megapixel camera, a high-quality JPEG file is about 3 MB and a RAW file about 7-10 MB.

You can see from the chart above that if you shoot RAW files you need a lot of memory card megabytes. You can get by with much less when shooting high-quality JPEG. When you consider that they can

be used again and again—making the per-picture cost very low—per cards are not expensive. With digital cards, there should never be an excuse for running out of film.

These numbers aren't an exact indicator of how much capacity you need in a card. You will usually be able to shoot much more since it is rare for most photographers to shoot without erasing junk as they go. Some photographers keep everything, and a sports photographer, in the heat of action, isn't going to pause to erase images.

Since JPEG is a variable compression technology the numbers are an estimate. If you shot a lot of people in a studio against a solid background, you would find the files compressed smaller than pictures of landscapes (though both are the same quality). JPEG cannot compress a highly detailed image as well as something with solid color.

If you want to try one of the really large cards, make sure your camera can handle it. While cameras purchased in the last couple of years will support these cards, the older cameras cannot support cards larger than 2 GB.

Memory card capacity does not affect the quality of an image. However, it does determine the number of images you can hold per card.

You will also need to consider how to buy and use your memory cards. Do you buy one big one and never change cards? Or would a number of smaller ones better meet your needs?

• Downloading Memory Cards

Once you have your photos stored on a memory card, you will need to record them elsewhere. While you can print directly from your card or camera, after a while you won't be able to shoot any new images because the card will be full. Typically you want to get photos off the card so they can be used in other applications and to clear your card for reuse.

There are three main ways to download your memory card and its images: access through the camera, removing the card from the camera for downloading on its own, and taking the card to a photo-processing lab. Each has its advantages and disadvantages.

All digital SLRs offer the ability to transfer images from card to computer (or other storage device) with a direct connection from camera to computer. This usually involves some sort of cable (typically a USB or FireWire connection) although infrared and other wireless technologies may be seen in all digital SLRs in the

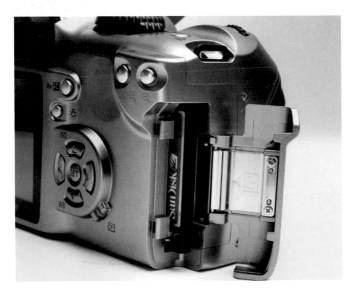

Slide the memory card into the camera and close the compartment door. In a way, this is exactly like using film—remove full cards and replace with empty cards, or switch from card to card, as needed.

The type of photo shot, RAW or JPEG, will affect how big a memory card you need. RAW files take up more space than JPEGs.

future. The type of camera connection cannot be changed—it is built into the camera.

The advantage of FireWire is speed. It is a very fast way of connecting devices. USB comes in two versions, 1 and 2. The older type 1 is only moderately fast—considerably slower than FireWire. Type 2 has specs that rival FireWire (also called IEEE1394 and i.Link), yet in practical application it is usually slower.

Downloading From the Camera

You don't need to remove the card from the camera and you don't need any additional devices. When you use your camera for downloading, you simply hook one end of the cord to a port on the computer and the other end to the camera. When you turn on the camera, computers with the latest operating systems will usually recognize it and help you make the transfer. If not, you'll have to add the camera's software.

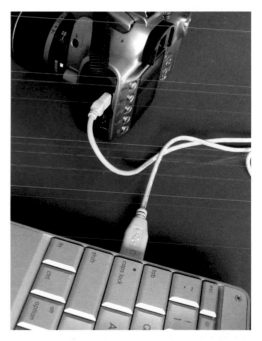

You can download photos directly into a laptop while you are traveling. A browser program like iView MediaPro will help you sort and review them.

Depending on what imaging programs you have on your computer (and the camera's software), you'll often find a program to help you move photos onto the hard drive. At this point the digital image files are being copied from one place to another.

Hint: Pay careful attention to where these files are going. Too often the files end up somewhere on the hard drive—but where? If it is not clear, the program will usually tell you in Options, Preferences, or Tools.

Card Readers

Card readers are the preferred way that most photographers transfer images. Readers are the fastest and simplest method. A card reader is a small, stand-alone device that plugs into the computer (USB or FireWire), and it has a slot for your camera's memory card. While these readers come with capabilities of reading different card types, you will probably just want the simple, less expensive unit that just reads the type your camera uses.

The card reader is easy to use and very affordable. In a way, it makes your camera act like the traditional film camera. You sim-

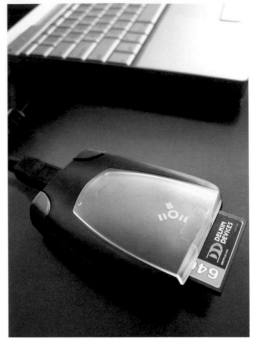

Most photographers prefer to use a card reader to download images to the computer. Card readers are readily available, relatively inexpensive, and are faster to use than the camera's connecting cord.

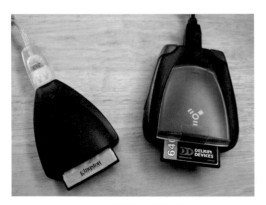

Card readers come with USB and FireWire connectivity. If you have FireWire on your computer, look for that type of reader, as it is very fast.

ply take your "digital film" out of the camera and put it into the slot for "processing." The computer will recognize the card as a new drive. (On some older operating systems, you may need to install a driver for the card reader, which will be on software that comes with the unit.)

The card reader now allows you to work with the image files. If you are not familiar with how computers deal with files, transferring images may take some learning. But if you have even basic computer skills, you will find that this reader now allows you to work with the image files just as you would any other files—like selecting all the photos and copying them to a new folder.

Working with Card Readers

- Set up a folder ahead of time so you know where to put the images.

- Card readers are faster than downloading with a connected camera.

- No special camera software is needed.

- It is always connected, so you are not struggling with unused cables.

- It uses little space on the desktop.

- You don't have to have the camera on the desktop where it can be accidentally knocked off the desk.

- If you don't have FireWire speed on your camera, you can get it in a card reader.

Experienced digital photographers recommend always using the camera to reformat and erase a card. This eliminates problems with the card's directory, which may occur if the card is reformatted in the computer.

Finally, I would strongly suggest checking out a FireWire reader. While more expensive (and requiring a FireWire port on the computer), it is a great convenience because it downloads files so very, very fast. This can be very important if you have big cards filled with images.

Laptops with FireWire and USB connections work in the same way. Some even have slots specifically for memory cards (usually the common CF card) for direct transfer. Most Windows laptops also have PC card slots (the old PCMCIA slots) and you can get memory card adapters that fit into these slots. Transfer of images from these slots can also be very, very fast.

Taking Your Card to a Lab

Many photo enthusiasts are finding another way of transfer quite attractive—using a lab. Take your memory card to the minilab where you, or the lab, download the

images and make prints. It's just like dropping off film. Many labs have self-service kiosks that allow you to do digital photo printing directly. Some cameras even have a DPOF feature (Digital Print Order Format) that allows you to select in camera which shots your processor will print. These prints are made on photo papers just like traditional film prints.

The major benefit of using a lab is that you can take advantage of a digital SLR without using or owning a computer. By going to a lab, you can get those prints done fast and easy. Most photographers—whether pros or amateurs—will take casual images that only require quick prints for friends and family.

• Clearing the Card

You've downloaded your images. Now what is best way to erase images off of a memory card—camera or computer? It's just data, right? So why not erase from the

Be careful that you do not erase favorite images from your memory card until you have downloaded them. You can protect individual shots from erasure on most digital SLRs by using the protect section of the menus.

computer after downloading images? Some photographers do, and there is even software that seems to encourage that. Minilab operators may offer to do it for you. However, before making this decision, it helps to know what erasing and formatting a card actually does.

Erasing the Card

When a memory card is erased, no image files are actually destroyed or removed from the memory. (This is true for all computer files when erased, which is why they can be a security issue in secret government locations). Erasing removes only location/identification data that tells the computer where the file is located. Once this location/identification data is removed,

new photos can overwrite the old image file. Once new photos are saved, the original photo is "lost" since its information has been overwritten.

Reformatting the Card

When formatting, the camera or computer completely rebuilds the directory structure of the card (which tells any device reading the card how to find the data). This results in the "erasure" of the photos by removing locating links to the actual data.

Caution: Changing this directory is tricky since cameras and computers have slightly different file structures—so changes from the wrong device can adversely affect the card's performance.

All of the technical gurus I have talked to recommend using the camera for erasing and reformatting of the card. Formatting your card in the camera lowers the risk of corrupting or accidentally changing the file system of the card.

Caution: *It is actually possible that formatting a card with FAT32 or NTFS (computer formats) could make the card unusable in the camera. This can usually be fixed with a reformat in the camera.*

My friend and digital expert, Tim Grey, has an interesting take on this:

"Reformatting in the camera causes the card to be re-initialized, helping to avoid possible problems with the FAT (file allocation table—the directory) data becoming corrupted over time." He adds, "I don't like to erase the card until I am actually ready to use it. This then serves as a last-resort backup for the images as long as they are sitting on the card. I then have to make a conscious decision to remove them rather than a casual delete at the computer."

What if you have more than one brand of camera? Generally speaking erasing or formatting in different cameras has little effect on the card. Worst case: The picture count for the card is thrown off.

Hint: It is a good idea to reformat your card every month or so if you are a casual shooter, perhaps every week or two for high-volume photographers. Some photographers like to reformat every time they put a card back into the camera. There is nothing wrong with that and no harm will come to the card.

• Field Storage

When you are shooting, cards do fill up. Eventually you will want to download images while shooting to empty your card to take more photos. For me, a more

important reason is back-up. With traditional photography, if you lost or damaged the film, your photos were gone forever. With digital you can back up all of your digital images with exact copies and rarely lose photos. I tend to backup photos every day that I am shooting—whether I am using up cards or not.

You could keep a lot of memory cards with you (they are becoming quite reasonably priced), or buy some very big cards. I think it is very important to take advantage of the backup ability of digital. Since you can, why not back-up your files—especially with photos that are very important to you?

Downloading to Your Laptop

Small laptop computers and dedicated handheld digital storage devices are good solutions. Personally, I prefer a small laptop with a built-in CD-burner—many pros like this choice. The laptop allows you to download images to its hard drive, review them on the bigger screen of the computer, edit as needed, and then make a backup copy on CD. Short of someone stepping on them, CDs are pretty durable and a good way to ensure you have your images.

Even photographers in the toughest conditions will find rugged laptops on the market designed to take abuse in the field—and still weigh no more than a couple of pounds.

Downloading to Handheld Storage Devices

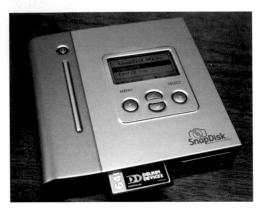

Above: CDs are not all alike. For long-term storage, look for CDs with archival qualities, such as these DataLifePlus CDs from Verbatim.
Left: This stand-alone CD burner allows you to record your images directly from a memory card to a CD without using a computer

Most are battery-powered, laptop hard drives with a built-in card reader (some even include a small LCD screen to allow you to see images). You simply plug in your memory card and the images are transferred quickly to the hard drive. For sheer size advantages, they can't be beat. They easily fit into a gadget bag so they can always be with you. However, since they are hard drives, you do have to be careful not to drop them.

Stand-Alone CD Burners

A few stand-alone CD burners are showing up, and we may see similar DVD-burners soon. These allow you to download a memory card directly to a CD, skipping the computer altogether. An advantage of a CDs is that you can make multiple copies. This can be very important for really critical work.

Some photographers need to get an image back to an editor immediately. Photojour-

nalists typically use either a laptop with cellular modem or a PDA with wireless capabilities for this purpose. They transfer the images to the computer or plug in the memory card to the PDA. Then with a little help from the communication or email program and the processing power of the unit, they send the images off instantly to their publisher.

Digital photography has given newspapers new capabilities to compete with television—showing the latest visuals from a newsworthy event. In film days evening events that appeared in photos in the morning papers only showed things that happened very early in that event. Now, the last shot at a basketball game, a key speaker at a rally, and so on, can all show up in the paper the next day. This will become increasingly easy to do in the future and nearly anyone will be able to transmit photos around the planet instantly.

Protecting Your Images
No matter how you download your pictures, you will have image data files that need to be protected. This is a really critical part of the digital age. You want to be sure that you can get your photos when you need them and that nothing terrible happens to them. Now, I can't offer you any-

Protect your photos by creating back-ups. An archival CD is a great back-up because it lasts a long time and can be read by all computers with a CD drive.

thing that would protect your digital photos from such a disaster as fire, although digital safeguards can actually help here, too, if you keep very important duplicate files in different locations. I know of photographers who actually keep duplicate files of important images in bank vaults.

A small portable hard drive that attaches to your computer can be a very useful backup device that allows you to make complete copies of your files on a device that can be

Since archival quality CDs can have lives of 80 years or more, CD-Rs are an excellent choice for backing up your images.

moved from computer to computer. These drives offer a lot of gigabyte storage space, making a huge number of images instantly available. They also come with both USB and FireWire connections for ease of use and speed.

Their disadvantage is that they are moving magnetic media—damaged by dropping— and the data fades with age.

Caution: *Data on magnetic media fades with time. Most manufacturers will only recommend 8-10 years for their media. While there is no doubt that this is a conservative number (many people are able to access magnetic data longer than that), remember that enough problems occur in this time frame that it is worth looking to backup images in non-magnetic ways.*

The recordable CD or CD-R is an excellent backup medium, as is the DVD. These optical storage media have a life 50-100 years depending on their quality. Cheap

CDs are fine for short-term storage (or backup) but—if you want your photos to last—look for disks with distinct claims for archival or long life. These disks are very stable in their data saving capacity. You do need to protect the top from damage (this is the side with a mirror that reflects the device's laser), which may include writing on the CD with markers specially designed for CDs. Most computers today have CD-R/RW drives and CD-writing software has become drag-and-drop simple. The CD has become a common way of storing and transporting images for photographers.

I have intentionally not mentioned rewriteable CDs or CD-RW. While you can use them to transfer any type of file from one computer to another, or for temporary storage, they should never be used for image back-up and safe storage.

Caution: CD-RWs are designed to be erased and reused, which means the medium is meant to change! No photographer wants a storage medium that might change.

After photographing with a digital camera, I nearly always immediately make a copy of all my unmodified files to a CD. They become like my film archival negatives. I can always go back to them. I then keep this CD in a safe place and can make duplicates for very important work.

DVDs

DVD is rapidly becoming another very important optical storage medium. Since DVD drives do CDs as well, you may end up doing the smaller CDs for basic backup. The advantage of DVD is storage space, but you don't always need or want it. Several less-expensive CD's may help you keep your files better organized than a single DVD. Yet, when you need the added storage, DVD is great.

With a CD you can get up to approximately 700 MB of data on one disk (this has a slight variation depending on the disk). While DVDs are rated at 4.7 gigabytes, for a variety of filing and technical reasons, you cannot record that amount of image files on one. You actually get a little more than 4 GB of usable storage—still quite a lot. Currently a single DVD will hold the equivalent of nearly six filled CDs.

As digital SLRs increase in megapixels (and RAW capture becomes more commonly used), you will go through a lot of storage space. A big vacation could easily fill up a CD. As you use layers when working on photos in the computer, you can get individual files reaching 100 MB or more. A DVD gives you a lot more flexibility in storing these.

The unfortunate part about the recordable DVD is that the manufacturers have not agreed on one single standard. There are competing formats, although DVD-R and DVD+R are probably the most important for photographers. All DVD formats other than DVD-RW work well for image back-up and storage (the same thoughts about CD-RW apply to DVD).

• Digital Workflow

Working with film used to be pretty simple: Buy the film, put it into your camera, shoot the film, take it out, and get film processed for prints or slides. Digital is

Before venturing out with your digital camera, increase your success by preparing for the shoot. The checklist provided here will get you started, but you will probably develop your own as you gain experience with your camera.

vastly different. Sure, if you simply took all of your memory cards to the local mini-lab for prints the process would be similar. With digital, however, there are some new things to consider as part of your way of working. If you do download images and work on them in the computer, the process gets even more involved.

A couple of years ago, Canon came out with an excellent educational CD about digital. I was very impressed by it and incorporated some of the concepts into my own work as a photographer and writer. To give you some ideas on developing your own effective way of working digitally, this chapter—building on some of those Canon digital workflow ideas as a starting point—offers my personal interpretations and additional tips based on my experience.

Before You Shoot

In the film world you needed to be sure that your camera was clean, your batteries were fresh, and that you had enough film. That was really about it. For digital we add some things:

1 **Check batteries**—If your batteries have been unused for any length of time, be sure to recharge them.

 Hint: Batteries lose power just sitting. Be sure that you have enough backup power.

2 **Check your sensor**—A dirty sensor can be a problem. The easiest way to check it is to take a random photo of the sky and see if out-of-focus blobs show up anywhere.

 Hint: Magnify the image and scroll through it on the LCD. If you find dirt, read your camera manual. It is vital that you follow the manufacturer's specific instructions for cleaning the sensor.

2 **Format your memory cards**—This is a good time to confirm that you have downloaded important images from the cards and they are ready to go. Formatting them cleans up the file structure and puts them in the best condition for receiving new images.

4 **Set up your camera**—This simply means checking settings for saving images, white balance, ISO, and so forth. Ironically, it can be a real lifesaver if your last shoot was at a setting that is completely wrong for your current subject. It can be very disappointing to find you did not have the camera set right for some critical photos.

5 **Do test shots**—With a new camera lens or technique, you should always do some tests to be sure you are going to get the images you want. A few early tests can save a lot of frustration later.

6 **Prep your camera bag**—Be sure you have everything you need; especially two extremely critical parts of your camera kit that can be easily misplaced—batteries and memory cards.

During Shooting

It is a good idea to get into a habitual way of working so you don't forget an important setting. Sure, you can correct mistakes in the computer, but a series of wrong exposures will just waste valuable time. Many of the points below follow good habits for working with film cameras. Here are some things to look at:

1. **Metering mode**—If you never change this it isn't a problem. However some cameras have their on/off switch on or near the metering mode dial, so it is possible to accidentally change the mode. Be sure you are in the mode you want.

2. **Autofocus**—If you are like me and use both auto and manual focus, or if you change AF modes, it can be scary if you forget to check AF settings as you go. It's easy to choose a manual setting on a wide-angle lens and then forget about it—only to discover later that you were sure it was auto focusing when it wasn't!

3. **Custom functions**—Many digital SLRs have custom functions that allow you to make the camera work in special ways such as changing the function of a button. If you don't use custom functions, check your manual and you might discover some settings that you could use. If you do use them, be sure the custom functions are set the way you want.

4. **White balance**—This new digital function is a critical part of your digital SLR. With experience, most photographers start changing this regularly. The trick is to always do a quick check to be sure it is set correctly for each new scene.

5. **Review**—Is your review on long enough after taking the picture? If it is too short, you'll quickly get annoyed. If it's too long, you can always shorten it by pushing the shutter release. However this can be a problem if you consistently forget since your batteries will then lose power faster.

6. **Protect and erase**—Do you know how to protect key images? That function is usually in the menus. This can be helpful to ensure that you never accidentally erase an important photo. Also when you protect just the photos you want, then erase "all" the images on the card (not format), you save only the protected shots.

7. **Organizing images**—If you care about how the camera handles image file names you may want to be sure your camera numbers in a way that is logical to you.

 Hint: Look into setting up different folders for groups of photos.

Transfer Images

You'll find quite a bit on transferring photos from camera to computer on page 97-99. This brief overview offers a workflow to keep them organized:

1. **Identify your destination folder**—It might seem like the best thing to do first would be to connect camera or memory card to the computer. Actually it really helps to identify or set up a destination folder for the downloads first, then start downloading.

2. **Connect camera or memory card to your computer**—Plug in the camera or put the card into the reader.

3. **Access the image files on the card or camera**—Drag and drop them into the destination folder you indentified in step 1.

Browser programs, like ACDSee from ACDSystems, are extremely helpful in downloading, reviewing, editing and sorting photos. They are a lot like the old light table for slides.

4. **Do a visual check**—Use a browser program (such as ACDSee or iView Media Pro) to confirm that your photos are all on the hard drive and okay.

5. **Back up**—Back up your image files to a CD or DVD.

Browse Images

I love to look at my photos once they get into the computer. I enjoy seeing the subjects again and I get ideas about what I can do to improve them. Browsing your photos—just looking at them as if they were on a light table—is a very important way of working. This helps you quickly determine what works, what doesn't, and you'll discover trends in shooting that you might be unconsciously developing.

You can arrange photos and move them to any file folder you choose. For example, you could create a folder called "plants and flowers."

Once you open an image, always resave JPEG files as either the image processing program's native file (such as Photoshop's .psd file) or a TIFF file. That way, your original files are protected and you don't lose quality.

Now you can copy and move photos to subject specific folders on the computer. This allows you to set up different areas on the hard drive that are labeled with names specific to the shoot: "Los Osos August 05," for example. You can also create a folder called Favorites or Selects for your best shots. I will set up folders that are subject specific, such as Flowers and Soccer. I also label them as processed and unprocessed.

Processing Images

While this isn't a Photoshop book, it is important to learn how to set up a workflow for using your image-processing software. While many books that go into great detail about this, we'll only look at critical points.

1. Select the images you want to process. Again, image browsing programs can be very helpful in letting you see photos.

2. Process RAW files and "Save As" a TIFF or native image processing software file (such as Photoshop's .psd).

3. Once a JPEG file is opened, do a "Save As" for your working file so that the original is protected as a TIFF or native file.

 Caution: Never use JPEG as a working file format.

4. Decide on the level of processing needed, basic for a snapshot to high for a display print.

5. Crop and rotate the photo.

6. Examine your photo for overall color and brightness/contrast. Is it too bright or too dark? What colors are problematic?

7. Look at individual areas in a photograph to see where small parts should be adjusted separately from the whole image. Usually you will do this to balance a dark or light part of the image and to subdue or control areas around the subject.

8. Use selections and layers to isolate parts of the photo so that they can be adjusted separately.

9. Flatten finished files for final use and then sharpen the finished file.

 Hint: Reserve sharpening for this stage.

10. Save layered files and flattened files separately. This can make your use of images more efficient. The layered files let you go back and make adjustments while the flattened files are easier to use in multiple applications.

accessory lenses
& flash

One of the great advantages of a digital SLR is the range of accessories available, including lenses for any required purpose.

One of the great advantages of the digital SLR is its ability to use accessory lenses and flash units. Each camera manufacturer offers a range of lenses and flash units for all price points and photographic needs. Plus, aftermarket manufacturers also offer many good values in accessory equipment.

• Lenses

With a digital SLR you can chose from a whole range of lens focal lengths from wide-angle to telephoto, increasing your photographic possibilities. Between the lens choices available from the camera manufacturer and independent lens companies, your choices are extensive.

We will use two important conventions to talk about lenses with digital SLRs. The first is the use of 35mm equivalents. The other is that, even if we talk about a specific lens and focal length (such as a wide-angle lens of 28mm), it will apply to both a single lens of that focal length and to zoom lenses that include this focal length.

Digital Magnification

You'll find another section on digital magnification in Chapter 2. However, I am going to repeat a bit of this so that you do not have to skip back and forth. You need to keep the idea of digital magnification in mind so that you can understand how a wide-angle or telephoto focal length works with your camera. Digital cameras do put an interesting spin on focal lengths. Since the sensors are generally smaller than 35mm film, they change what can be seen with a given focal length. This is not just a minor technical difference. In fact, they are a different format—as much as 35mm is a different format from 2-1/4.

A lens' focal length is meaningless without a reference to the image area—or frame size—within the camera. As noted earlier, a 75mm lens for a 4x5 camera is a very wide-angle lens. A 75mm for a 6x6 camera (medium format) is considered a "normal" lens. A 75mm lens for a 35mm camera is a short telephoto. A 75mm for an APS camera is a longer telephoto, and 75mm for a miniDV camcorder could be a super-telephoto.

The effect any lens has on the subject depends on the sensor size. Small-format sensors magnify the image with a given focal length compared to what a full-frame sensor (35mm size) will see with the same lens.

became, in effect, a different format. These sensors were then used in a 35mm-style body that accepted the same lenses, so the only way to compare them was to use a magnification factor (35mm equivalent). Since the angle of view of a lens is affected by the format, and there are at least four different digital formats (different sensor sizes) used in digital SLRs, the best way to talk about lenses in any generic way is to use this convention of 35mm equivalents.

When a lens is used on a small-format sensor (any digital SLR sensor smaller than a 35mm frame), it will act more like a telephoto compared to how it would act on a 35mm film camera. A magnification factor is used to give an approximate idea of how a focal length on the digital camera compares to a lens creating the same image on 35mm. This factor depends on the camera and ranges from 1.5-2x. You then get a 35mm equivalent of your lens compared to 35mm film.

The 35mm focal-length equivalent is something most photographers can relate to. This got started because manufacturers wanted to create digital SLRs that would let photographers use lenses they already owned. Unfortunately, the technology to make 35mm-sized sensors was too costly, so manufacturers made small sensors that

Lens Speed

Before we go further with lenses we need to look at lens speed, as this is one area that isn't always well understood and can cause some major problems for a photographer. Lens speed refers to how much light a lens lets into the camera at its widest aperture—the maximum f/stop. This is the number that is always given when referring to a lens and its focal length. For example, a 300mm f/2.8 would be a 300mm lens with a maximum aperture of f/2.8. The wider the aperture, the faster the lens. So an f/2.8 lens is faster than an f/4 lens.

This gets tricky with zooms. Many zooms have variable maximum apertures so a lens might be 28-90mm f/3.5-5. This would

A single-focal-length lens is faster and often smaller than a zoom that has the same focal length, but it is less versatile since the focal length is constant.

mean the lens has a speed of f/3.5 at 28mm but it drops to f/5 at 90mm. In-between focal lengths have in-between f/stops. The reason lenses are made this way is size. A variable aperture lens can be made a lot smaller than a constant or fixed aperture zoom. This can be a huge advantage when size and weight are important.

Wide-Angle Lenses

A wide-angle is one of the fundamental focal length categories for the photographer. Wide-angle lenses have the ability to take in more of a scene from left to right and top to bottom. The difference between a wide-angle and any other lens is somewhat arbitrary and is based on a focal length's relationship to a "normal" lens for a given format. In 35mm, that normal lens is approximately 50-55mm (which is related to the diagonal of the format). The wide-angle is then any focal length that is shorter. Remember, these are all 35mm film camera equivalents.

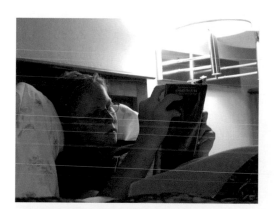

A fast lens allows you to shoot under very low light conditions with faster shutter speeds and can be more easily focused in low light as compared to a zoom.

Why is Lens Speed Important?

- **Handholding**—A lens is best handheld at higher shutter speeds. Higher shutter speeds require wider lens openings. This can create a real chal-

lenge for zoom lenses. For example, if the exposure may be a reasonable 1/125 second at f/3.5 that drops to 1/45 second at f/5, which isn't the best shutter speed for anything other than a wide-angle. If you are not careful you can find that, although you get sharp photos with the wide-angle end of a variable aperture zoom, softer photos result at the telephoto end due to camera movement during the exposure.

- **Low-light conditions**—Fast lenses become very important when light levels are low (such as available light shooting indoors or at night). A wider maximum lens opening offers the ability to use faster shutter speeds to stop action and makes the camera easier to handhold. It also makes autofocus work better and the viewfinder easier to view in dim light situations.

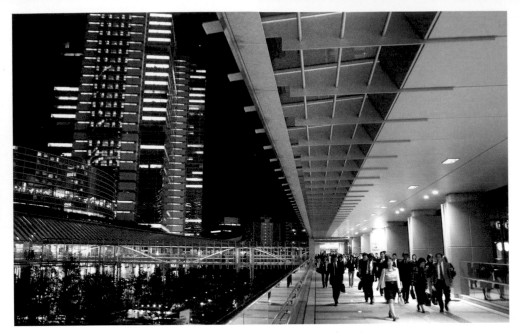

A wide-angle lens captures dramatic perspectives that simply cannot be captured any other way.

The 35mm focal length used to be very popular with photojournalists. It is wider than normal, but not so wide as to call attention to itself. In "prime", or single-focal-length lenses, it is typically quite fast—f/2 or even f/1.4—which makes it ideal for low-light light conditions. This focal length is very common in zooms.

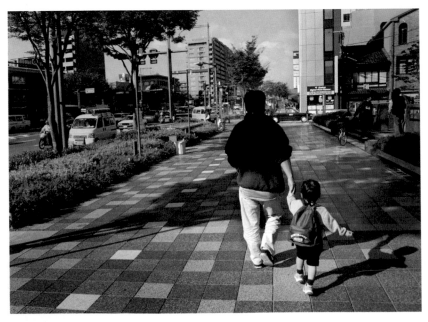

A zoom with wide-angle focal lengths is a great tool for street photography. The wide-angle selections give you the chance to reveal more of your subject's surroundings and provide a sense of place.

Full-frame fisheye lenses let you photograph very big subjects in confined spaces, but they do curve straight lines.

Probably the most popular wide-angle focal length is 28mm. This is wide enough to really make a change in what you see of the scene. You don't have to change many numbers in a focal length to make a big change in the wide-angle range. The 28mm lens is very commonly available at all prices (even when digital magnification is taken into account).

Lenses that were extreme wide-angles for 35mm become important as standard wide-angles for small-format sensors since these sensors lose some of the wide angle that the lens sees.

The next step is the 20-24mm range. These focal lengths offer some impressive changes in angle of view and perspective. They start showing distinct wide-angle effects—like verticals strongly leaning in from the edges when the camera is pointed up. Many photographers like these lenses for indoor work as well for the dramatic effects they offer.

Drop below 20mm and you get into the range of the superwides. They offer dramatic changes in what you see and extreme wide-angle effects. They can be hard to use because, while they give a lot of width to an image, they also include a lot of foreground area that may be unwanted. In this range you'll also see the super superwides in two choices: rectilinear and full-frame fish-eye.

Rectilinear means the lens is corrected so that straight lines in the photo stay straight. Full-frame fish-eye makes straight lines that are strongly curved as they near the edges—an interesting effect—and since

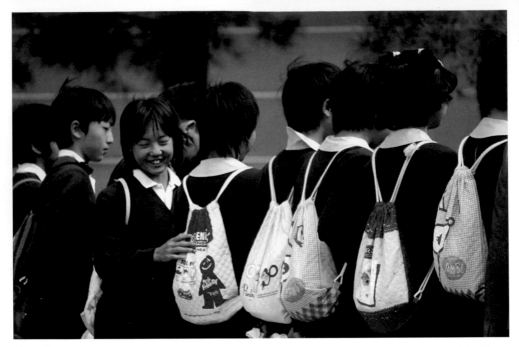

A telephoto lets you isolate and magnify action and detail in a scene. It also lets you minimize depth of field for a stronger photo.

the lens doesn't have to "straighten" lines of perspective (as a rectilinear lens does), it actually sees a wider-angle of view.

Telephoto Lenses

Telephoto lenses are just the opposite of wide-angles with their ability to zero in on a scene, magnifying it in the viewfinder and at the sensor. They also allow the photographer to step back from the subject and still get a reasonably sized image. The difference between a telephoto and any other lens is also relative to its relationship to the "normal" lens. Telephoto lenses are any focal length that is longer than "normal" and are also referred to as "long lenses." Single-focal-length telephotos tend to be much faster than the same focal lengths in zooms.

The 80-90mm size is a moderate range that used to be very popular with photojournalists. It is slightly longer than normal yet not so much of a telephoto as to call attention to itself. In "prime," or single-focal-length lenses, it is generally quite fast—f/2 or even f/1.4. This focal length is also very common in zooms. Many small "standard" zooms will have 35-80mm or 28-80mm as focal lengths, which are good portrait lenses for showing a bit of the body as well as face. Another very popular portrait focal length is 105mm, which gives the photographer a good distance from the subject and creates a pleasant facial perspective.

Hint: Wider angles tend to distort our perceptions of a face.

Many zooms have focal lengths covering the range from 135-200mm. This repre-

sents a good set of telephoto strengths. They are long enough to allow you to get subjects that are not right next to you, but are still reasonable in size and cost. Single-focal-length lenses in this range can be quite fast.

The 300-500mm range of focal lengths offers a lot of magnification. Compared to a 50mm lens they offer 6-10x power. This is why wildlife photographers and sports photographers prefer these focal lengths. The lenses start to get big and expensive, however, and fewer zoom choices are available. Above

500mm and you get into the super-telephoto focal lengths. These extreme lenses are big and expensive but for certain types of photography—special effects and wildlife—they can be a necessity. A great advantage of the smaller digital formats is the ability to get the equivalent of a big, heavy, expensive super telephoto in a smaller lens.

A wide-angle lens (top) gives a feeling of depth and distance, yet a photo shot from the same spot with a telephoto (bottom), offers a very different look at the same subject.

Focal lengths and distance to the subject have a dramatic effect on perspective. The left photo was shot with a telephoto, the right with a wide-angle.

Evaluating Lenses

Criteria	Zoom	Prime
Quality	equal	equal
Versatility	high	low
Speed	slow to fast	very fast
Size	small to large	small to moderate
Weight	moderate to large	small to moderate

Zooms vs. Single-Focal-Lengths

When zooms first came out they had one major advantage over single-focal-length (also called prime) lenses—many focal lengths in one lens. However, they were not very sharp, had poor contrast, and generally could not compare to prime lenses. I bring this up because some photographers want to discredit zooms as if they are still inferior lenses. Old ideas can die hard—especially when they were once based on fact—but this is not true today.

Mid-priced and top-of-the-line zooms are as good as, or even better than, primes. You might wonder how they could be "better" since the best of primes are extremely good. This is because zooms are based on the newest and latest in optical design and technology, while most primes were designed many, many years ago. Even the cheapest zoom on the market today will give any lens a run for the money, and generally offer excellent quality. While they might not match a single-focal-length, or prime lens, shot wide open, they look very

Lenses are now being designed specifically to enhance digital photography—they use the latest designs for top quality, are optimized for the sensor and can be made smaller for small-format sensors.

Dedicated Digital Lenses

A number of manufacturers have begun to produce lenses designed specifically for digital cameras. There are three key benefits that these lenses offer that make them attractive choices for the photographer with a digital SLR:

1. **Size**—By making lenses that can only be used with the smaller format sensors (they only "cover" the sensor and can't be used with 35mm), manufacturers can make smaller and less-expensive lenses.

 Note: Some "digital" lenses can be used with film cameras too.

2. **Quality**—Since these lenses have new optical requirements they have to be designed anew. This typically means they use state-of-the-art optical designs so you can expect them to be of high quality.

3. **Optimized for sensors**—Since the sensing sites (or pixels) of a digital camera sensor work best when the light hits directly, there is some thought in the industry that image quality is improved with lenses that better collimate (aim) the light so that it hits the sensors more directly.

Manufacturers want you to know these are state-of-the-art designs, so the packaging will generally have prominently displayed references to digital cameras or photography.

good when stopped down. You give up nothing in quality by using a zoom, and gain a lot in versatility.

Zooms today have become the lens of choice for most photographers. You can get wide-angle zooms, telephoto zooms, and wide-to-tele zooms with all sorts of variations in actual focal lengths. You can get fast, constant f/stop lenses where the f/stop doesn't change with focal length. These lenses are larger and more expensive. Or you can get super-compact, variable f/stop zooms with extended range. Since zooms do so much, why bother with single-focal-length lenses? Many photographers will be perfectly satisfied owning nothing but zooms, but you should make a direct comparison between lens types by examining the chart on the previous page to see why you may need both.

You can see that each type stacks up against the other very well, except in two categories—versatility and speed. Zooms will always win the versatility race, but primes will always win the speed race. If you want the convenience of a lot of focal lengths in a single package, then zoom is the answer. Need speed for photographing indoors without flash? A prime lens is a better choice.

The close-up world is a dramatic place. Your digital SLR has many options —from high-quality screw-in to macro lenses—for capturing a close-up.

Getting in Close

Close-up photography is a fun part of using a digital SLR. Since you are focusing through the taking lens, whatever you see in the viewfinder for a close-up will be captured by the sensor. While many photographers think "macro lens" for close-ups, there are also other ways to focus close at high quality.

Add-On Lenses

You can use supplementary close-up lenses (sometimes called close-up filters) that screw on to the front of the lens. The inexpensive multi-lens packages can be useful for beginners, but the quality is marginal at best. I really can't recommend them. A better choice would be an achromatic close-up lens. This is a two-element glass filter designed to very high sharpness stan-

High-quality achromatic close-up lenses are expensive, but offer superb results and are less costly than macro lenses.

True macro capabilities bring you extremely close to your subject, down to 1:1, where the subject and its size on your sensor are the same.

dards. It is screwed onto the front of your lens and lets you focus very close. No exposure adjustment is needed. Final quality does depend on the lens under the filter, and these add-on lenses will only fit camera lenses with a specific filter size. These are available from Nikon, Canon, Hoya, and Century Optics, among others.

Close-Focus Zooms

This is a very convenient option, although the macro setting on a zoom does not make that lens a macro lens—just a lens that focuses very closely. While a few zooms are optimized for close-ups, most aren't, though they are much better than supplementary single-element close-up lenses. However, the fact that you can quickly get a close-up makes this a very versatile and viable option. Sometimes exposure adjustment is needed since, although the autoexposure will kick in, it does mean an f/stop or shutter speed will change.

Extension Tubes

These are literally empty tubes, without any optics, that fit between lens and camera (they are not teleconverters). They will usually have the necessary electronic connections to the lens to allow autofocus and autoexposure and they can be used on any lens, making them all (effectively) close-focusing. Extension tubes may not work on your wider-angle lenses and some special digital camera lenses can only use their own brand's extension tubes. Sharpness is dependent on the lens used and can be superb. Although extension tubes will cause some light loss to the sensor, the autoexposure will adjust with an f/stop or shutter speed change.

Note: Extension tubes are harder to use with zoom lenses. This is because zoom lenses focus "funny" with extension tubes—they will not stay focused when zoomed—and the zooming actually changes both focus and image size.

Macro Lenses

A true macro lens is one that is optimized for quality at close distances. It is designed for very high quality at 1:1 (an image size where the real subject matches in size the subject image on the sensor) and when the subject is magnified.

Images will be quite sharp no matter what f/stop is used (which isn't always true with the other options). It will also focus from macro distances to infinity without additional accessories.

• Teleconverters

A teleconverter (also called a tele-extender or multiplier) is a special device that fits between camera and lens. It multiplies the focal length of the main lens by a factor of 1.4x-2x (depending on the specific teleconverter). It can be used with any lens that will fit onto the converter (some lenses have optical elements at the back of the lens that will not allow them to fit a teleconverter) but many teleconverters are optimized for certain focal lengths or designed to be used with specific lenses.

The benefit of the teleconverter is that for lower cost and smaller size than a telephoto lens, you gain more telephoto power. Keep in mind that this accessory lens magnifies any defects in the original lens, too. Quite good quality is possible with a teleconverter, but they are best when used with a prime lens of the highest quality. If the converter is a "matched" lens that is designed to work with a specific lens or

Depending on the type of teleconverter you use, you can multiply the focal length of your lens by 1.4x-2x. (© Simon Stafford)

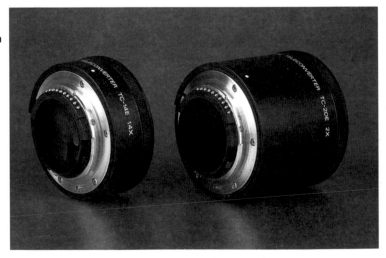

set of lenses, the combination can give outstanding results. As a general rule, zooms and converters don't necessarily like each other so results with that combination can be marginal.

A major downside to a converter is that it will cause the lens to lose speed. A 1.5x converter will cause the loss of one full stop of light. A 2x teleconverter will increase that loss to two full stops. This can be a serious issue if it makes the light level coming through the lens so low that too slow a shutter speed is needed or you have focusing problems.

You could try using the lens at its maximum apertures to get the most light but this creates its own issues. Lenses are rarely their sharpest at their maximum aperture and usually improve as they are stopped down a couple of f/stops. Consequently the teleconverter is magnifying both the lens focal length and the lower sharpness at the widest lens opening, so the combination rarely produces the finest results.

• Modern Technology

Lens manufacturers have managed to do some amazing things with lenses in the last 10-15 years. Computer design, new materials, and new technologies have allowed manufacturers to make better lenses for less money. They've introduced zooms with ranges that were impossible to create even a decade ago. Let's look at some important lens advances that can influence the quality and convenience of photography today:

Special Glass

Lens manufacturers have used special low-dispersion glass to improve the quality of telephoto lenses for quite a while. However, it is only relatively recently that manufacturing technologies have advanced enough to make this glass available for moderately priced lenses (they were very expensive). Many lenses are now built with these glass elements as part of the overall design. They get a variety of designations including: LD (low dispersion), SLD (super low dispersion), ED (extra low dispersion), and APO (for apochromatic). Whatever the name, they allow for higher correction of lenses, especially telephotos. Telephotos are highly susceptible to chromatic aberration—different colors of light focus slightly differently, making the image less sharp and lowering contrast. Lens manufacturers correct this with low dispersion glass. A few lenses have fluorite glass elements, which offer extremely high image quality with their very low light dispersion qualities.

Aspherical Lenses

This is another technology that has been around a long time but was very expensive. Today new lens manufacturing technologies allow aspherical designs to be included in inexpensive lenses. An aspherical element is a uniquely shaped lens that changes the way light goes through the glass on the outside compared to the middle. Wide-angle lenses have long been predisposed to spherical aberration. This occurs when light from the center of a lens and from its outer areas focus at different points causing unsharpness, blooming highlights, and other flaws. Aspherical lenses limit this problem and have become a common part of wide-angle and wide-to-tele zoom lens design.

Diffractive Optics

This is a new technology that isn't very common in lenses yet. Developed by Canon, it uses a diffractive grating (a thin optic that acts like a thick lens) to correct chromatic aberrations in telephoto lenses

High speed autofocus motors in modern lenses help the camera keep up with fast moving action. In combination with a fast AF system in the camera, they are a necessity for sports.

and improve their performance. This technology allows long lenses to be made significantly shorter and lighter. Better image quality in a smaller lighter lens—not a bad combination.

"D" or Distance Detection Lenses

Nikon was the first to come out with distance calculating lenses, which they call "D" lenses. Now most camera manufacturers do something similar. By using sophisticated electronics in the lens and camera, this technology lets the camera emphasize exposure metering on the subject (or at least whatever the camera is focused on). When the camera detects focus on a point, it tells the exposure system to put an emphasis on that area. This technology greatly increases the percentage of good automatic exposures.

High-Speed Motors

Lenses used to autofocus slowly and noisily. The motors were also in the camera body and not in the lens. Canon was the first to innovate with high-speed quiet motors built into the lenses (USM or Ultrasonic Motors). Nikon followed with their Silent Wave lenses. Sigma uses the term Hypersonic Motors. All of these motors are housed inside the lens and work quickly and quietly. If you never used an old autofocus lens, you may take this speed and audio level for granted. With older technologies (which are still around) lenses tend to grind noisily and operate slowly—searching for focus. High-speed motors with a new autofocus camera (digital or film) will snap in and out of focus very fast.

Image Stabilization and Vibration Reduction lenses use remarkable technologies that sense any camera movement and compensate for it with moving lens elements to give sharper handheld exposures.

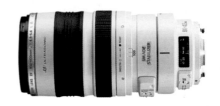

Image Stabilization

One factor that has always limited sharpness is the slight camera movement that can occur with slower shutter speeds. Image stabilization is a technology that allows the lens to sense movement of the camera and lens and then compensate for it. A small gimbal-mounted lens group moves to cancel camera shake and allow for much slower shutter speeds when shooting handheld. Typically the average photographer can expect sharp images at shutter speeds that are two to three full stops slower than would otherwise be possible. Image stabilization will also help photographers use large lenses on smaller (and lighter) tripods than normal with technology that reduces any vibrations that occur. This can also help photographers who have muscle tremors or other involuntary movements. Canon's technology is called IS for Image Stabilizer; Nikon's is VR for Vibration Reduction.

Lens Savvy

There are many lens applications that make big differences in your photography. Of course, with a digital SLR you can check the results of these suggestions in the LCD and determine how best to apply these variables.

Angle of View

Most people select a lens for their SLR based on the angle of view of the lens. How wide is the lens? How much of a telephoto which is a narrow angle of view?

This is certainly important. If you are traveling and expect to be taking pictures in confined spaces, nothing but a wide angle of view will do. If you are photographing a soccer game where the action takes place from near to far, you'll need a zoom lens that provides a whole range of angles of view. With wildlife, a telephoto is critical.

This is more than a subject consideration though. It is easy to be trapped into shooting with one focal length for a particular subject even though your zoom has more possibilities. Everyone shoots the soccer game with the telephoto angle of view, when a wide angle shot might be very appealing—showing off an interesting setting for the game. The wide angle interior might be the best overall shot, but zooming-in with a narrow angle of view can help you capture details.

I think the best way to deal with this is to take the shot first with the focal length that seems best suited for the subject. Then try an extremely different focal length—a telephoto for cropped-in details, a wide-angle to show off the environment. A portrait demonstrates this idea. Take the shot with the moderate telephoto focal length (such as 80-100mm in 35mm terms). From the same position, look at what a wide angle of view will do for you, and then try a more extreme telephoto. At this point, don't

Perspective is hugely affected by focal length and distance to the subject. This photo was shot up close to the lighting grid with a wide-angle lens.

move—use your focal lengths strictly for how much or how little they will show of the subject.

A variant of angle-of-view is magnification. Sometimes you really do want to think about magnifying a shot—getting a closer shot of a tiger at the zoo or finding an architectural detail in the ceiling of a cathedral. Since you cannot physically move closer to such subjects, the only way to do this is by magnifying the image.

Most digital SLRs have a built-in magnification factor when using lenses designed for 35mm cameras. As explained earlier (see pages 109–110), these cameras have a smaller sensor than 35mm film so they become a different, smaller format, just as 35mm is a separate format than a medium-format camera. The smaller image area of any different format will result in only the center part of a focal length being used to capture the image. This magnifies the subject within the format's frame. The result is that you get more magnification bang for the lens—a 200mm lens on a digital SLR for example acts like a 300-340mm lens would on a 35mm camera.

Perspective

Perspective is a major tool for image control—affected by lenses—and is heavily used by pros. Perspective is how we see size and depth relationships of objects within a picture. The classic example of this is a series of telephone poles going down the road. The closest one looks much bigger than the rest as a result of perspective. When you are far from the whole group they all look similar in size for the same reason. If two poles are photographed so that they look similar in size and appear close together, then the perspective is flat. If they are photographed so that the near one looks big and the rear one small (and distance appears between them), the perspective is deep. Knowing

Count the lights—these are the same identical lights as seen on the grid at the left. The difference is that these were shot with a telephoto lens at more of a distance.

how to control this with lens choice can give you a really great photographic tool.

Simply changing lenses does not change perspective. Perspective is a function of distance plus focal length. What if you photograph a scene with a zoom from the same vantage using both telephoto and wide-angle settings, and then enlarge the center of the wide-angle shot to match the crop of the telephoto? You would discover the perspective is the same!

Let's go back to the telephone poles and take two photographs: one with a wide-angle focal length and one with a telephoto (this can be done with a zoom or with different lenses). The trick is to take both photographs so that the foreground pole is the same size in each. This requires you to move close with the wide-angle shot (because the lens will see more in the scene making the pole small if you don't move in), or back up with the telephoto. The lens now sees a smaller section of the

composition because of the lens' magnification, so the foreground pole appears too big. This movement to or from the subject will keep the front pole relatively the same size—top to bottom—in both photos.

Now you'll discover some magic has been performed. While the foreground poles stay an equal size—the background poles are different! The wide-angle shot makes the back pole shorter while the telephoto makes it taller—in relation to the first pole. This is a perspective change.

Once you understand how to change perspective by changing focal length and distance, there are many things you can do. One is to play with sizes of subject and background to make your photo stronger in composition, and for creative effect. You could use a wide-angle to put some distance between your subject and background. Make your subject dramatic and big—up close to the lens—while the background appears small. Or you could use a

Depth of field is much more than what is sharp or not in a photo. It also affects what out-of-focus areas look like. Notice the background in both images—one is more defined because of the greater depth of field.

telephoto to close down the distance between subject and background. Make your local road look like LA at its worst: Get out that telephoto to compress the distance between cars.

These techniques can be used in very practical ways. Suppose you want to take a portrait in front of a dark doorway but the doorway is too small to really do the job. Back up and use a telephoto focal length to enlarge the door compared to the subject. Have some fun with a person's face. Use a wide-angle lens and get very close. This will make people's faces look odd, with big noses and "deep perspective." This is a lot of fun to do with kids and pets. You can also do things like stretch a car or make a house look longer.

Depth of Field

Depth of field is the sharpness in depth from front to back in a photograph. It is what allows you to have both a rock in the foreground of a photograph and the mountains in the background in equally sharp focus. Four things influence depth of field: f/stop distance to the subject, the size of the print, and the focal length.

Controlling Depth of Field

f/stop—Small lens openings (the big numbers such as f/16) increase depth of field, and large apertures (such as f/2.8) decrease depth of field.

Distance—The farther you are from the subject, the greater the depth of field. The closer you get, the shallower depth of field becomes. (This makes close-up photography a real challenge at times).

Size of the print—Small prints appear to have more depth of field, and as you go to larger prints, the differences in sharpness among various parts of the photo become more noticeable, so apparent depth of field decreases.

Focal length—Wide-angle lenses (short focal lengths) give greater apparent depth of field while telephoto lenses (long focal lengths) reduce depth of field. Many photographers do not realize that—even with a single zoom lens—they can increase depth of field by changing their zoom from wide to tele.

When you need to have a scene appear sharp from close to far, use the wider settings of your zoom or change to a wide-angle lens. If you want to limit sharpness through a selective focus technique (where one depth is sharp and everything else is out of focus), try using a telephoto lens or a more distant setting. These are not just techniques to use when photographing big scenes like a landscape or a city street—they apply to photographing everything

Digital Formats and Depth of Field

Smaller format digital SLRs have shorter focal lengths for their lenses compared to 35mm (e.g., depending on sensor size, a 50mm lens on a digital SLR might act like an 80mm telephoto on a 35mm film camera). This means that photos from these cameras can show more apparent depth of field than bigger sensor cameras. Depth of field here can be limited by using longer focal lengths and by choosing wider lens openings when possible.

from close-ups to portraits. Your close-ups will change dramatically when the depth of field is controlled.

Color

Color is also affected by your lens or focal length choice. It is true that cheap lenses from years past could affect color negatively, but I am not talking about lens quality. All lenses affect color when different focal lengths are used.

Wide-angle lenses (or zoom settings) tend to define color as distinct areas of sharpness and every little color shows up in the background or surrounding the subject. This is because wide-angle lenses deepen perspective (showing off more small colors in the background as more background is seen) and increase depth of field (which makes all details, including color, sharper).

Telephoto lenses do the opposite and blend and soften colors. This happens because these focal lengths typically offer less depth of field. Thus out-of-focus colors soften and blend quite readily. These lenses also compress distance (the perspective effect), which brings background colors closer together while also narrowing the angle of view, showing fewer of the colors of a scene.

Getting in close to a foreground with a wide-angle lens gives an expansive feeling to an image.

Experiment with Your Lenses

I am a great believer in experimenting with focal lengths. Even though I have been photographing for many years with many cameras and lenses, I still like to play and push the limits of my lenses. Here's a good exercise that will get you into the mode of fully using your focal lengths' capabilities: Try shooting alternate images with radically different focal lengths. Put on a zoom. Take one picture with the widest angle setting. Take the next photo at the most zoomed-in telephoto setting. Zoom out for the next photo, zoom in for the following, and so on.

Rather than simply adjusting the zoom, try to make each photo a distinct composition with an arbitrarily chosen focal length. Sure you could "cheat" on this exercise and tweak the focal lengths for

The telephoto gives a different, more compressed, even abstract, feel to a scene. Compare this moderate telephoto shot to the wide-angle opposite.

the subject but you'll get more out of it if you don't. It works best if you use some extremes—a wide-angle vs. a telephoto, not just one shot a little wider than the other.

Another good exercise is to shoot a series of photos (set a number such as 10 or 20) with one focal length. Try shooting every photo of that group of images with the same wide-angle lens or zoom setting—or with the same tele-

photo. This can be extremely challenging but it will get you to see what that focal length sees.

Whatever you do, have fun! The great thing about digital cameras is that you can't waste film in your experiments and you can erase your mistakes. Why not give these ideas a try and discover what lenses can really do for you and your photography?

Both manufacturer's lenses and independent brands can provide you with a variety of quality lens choices to suit your style of photography.

Modern lenses are made to very high quality standards. Lenses from the camera manufacturer have a certain consistency in form and function. Independent brands often offer a lot for lower prices.

• Manufacturer's Lenses or Independent Brand?

With interchangeable lenses comes a unique choice: Do you buy lenses made by the camera manufacturer (called original equipment manufacturer or OEM) or an independent lens manufacturer (called "after-market")? Although there are reasons for either choice, the good news is that almost all lenses today deliver high quality images. Having looked at a lot of lenses from different companies, I find that low-priced lenses from various manufacturers are really pretty similar in quality. In fact some of these are the same lenses with different branding (and often different finishes). In the low-priced arena the maker of lenses might not be the one branding the lens.

To some degree you get what you pay for—no matter what the lens or manufacturer. Higher priced lenses feature the most advanced optical technology (such as low dispersion glass), sturdier construction (so they hold up to heavier use), and the best in multicoating and interior baffling (to reduce flare inside the lens). However low-priced lenses can produce very high quality images, and offer great value.

With manufacturers' lenses you get a certain consistency in form and function. Functional controls are located in similar places from lens to lens, and the lenses tend to handle in similar ways.

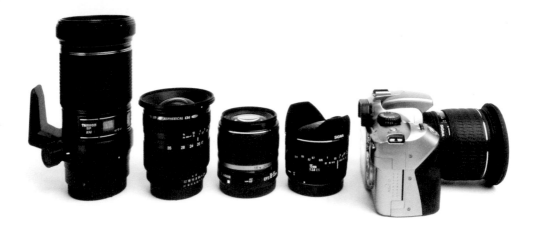

The proper lens package for you offers lenses that fit your specific photographic needs at a price you can afford.

Camera manufacturers' lenses usually have the latest technological innovations (such as image stabilization) and always communicate properly with the camera body.

Independent manufacturers' lenses are usually less expensive for similar quality and sometimes offer lens choices not available elsewhere. Don't expect a $200 independent lens to favorably compare to the same type of lens at $1200 from the manufacturer, though you might find a $700-$800 after-market lens nearly equivalent. There is nothing wrong with buying an independent brand lens for your camera. If it meets your needs and is at the right price—go for it. I have rarely been disappointed with today's lenses from independent manufacturers. If you shoot casually and mainly print small images (8 x10 inches or smaller), you may find little difference in shots from a lower-priced independent brand vs. any other higher-priced lens. However, if you need features like low dispersion glass and other technological advances—the added cost of these features may well be worth the price.

• Protective Filters

Many photographers use either a UV or skylight filter in front of the lens for "protection." Yet you'll find very few professional photographers using one (I don't even own one). A lot of photography retailers sell these filters by claiming that they give you peace of mind. You've just spent a lot of money on a new lens and it seems logical to want to protect your investment. A few dollars spent on a filter seems to be cheap insurance. There are reasons to use a protective filter on some occasions, but there are good reasons why you shouldn't leave it on your lens all the time.

• Lens damage is rare

• Lenses have hard coatings on the outside elements. Most photographers never put a camera in a position that could cause a scratch on the front lens. A hard impact to the front of the camera could be a problem, but if this happens, a filter probably won't help much.

- Filters give a false sense of security. I've noticed that photographers who don't use protective filters seem to take better care of their lenses. A dirty filter is no better than a dirty lens and I have seen far more dirty protective filters than dirty unprotected lenses. Dirty filters are also more susceptible to scratches so they often look bad—encouraging people to think that it was a good thing their lens was "protected."

- Inexpensive filters cause unsharpness. An expensive lens has very precisely arranged optics and an inexpensive filter can throw this off. It is actually possible for a cheap filter to transform an expensive high-quality lens into a soft-focus, poor-quality lens.

- Unnecessary filters increase the chance of flare. A filter is a flat surface. When you shoot toward the sun a lot of light hits the front of the lens and its first elements. Some of this is reflected back at the subject. If a filter is in front of that lens, its flatness can act like a mirror and reflect ghosted images of that light.

- Too many filters on a lens cause sharpness problems and possible vignetting. If one filter sits on a lens all the time, any filter used for photographic reasons (such as a polarizer) can compound sharpness degradation. Also, stacking filters can cause the filter to get high enough to be seen in the corners of the photo. This is called vignetting.

If you really do feel safer with your lens protected, there are two possibilities that will minimize the problems listed above. You could use a lens shade—a protective tube that extends in front of the lens. It will block light from striking the front of the lens and cut down flare. It also keeps fingers, branches, and a lot of other things away from the front of the lens. If you still want a protective filter, use a high-quality glass UV filter. Try the super-multicoated type, which cuts flare. A skylight filter has no effect on a digital camera due to white balance.

A lens shade will do more to safeguard a lens from damage than any protective filter. Plus, it will enhance contrast and detail by reducing flare.

A blower such as this ear syringe is an important accessory for keeping lenses clean. This is a simple and non-damaging way of removing dust, lint, and other debris.

Dirt on the Lens

Suppose you do get dirt on your lens. A filter is easier to clean right? Maybe—but dirt can cause sharpness and flare problems on a filter or a lens. You do need to keep your lenses clean. A filter is very easy to clean but—done correctly—a lens is easy to clean too.

• Maximizing Image Sharpness

Many photographers get less sharpness in their images than the camera's sensor is capable of rendering from the lens being used. This is really a shame considering the high quality of lenses today. This results from a very common problem: the camera moving slightly during the exposure. On a good tripod, this doesn't happen. When you are handholding a camera, it is free to move or "shake." A fast shutter speed will "freeze" the movement to maintain sharpness, but at a certain point the shutter speed will not be fast enough and blur will occur.

Many very good photographers don't realize that this problem doesn't simply mean obviously blurry or fuzzy photos. Very slight camera movement while the shutter is open will also decrease contrast in the image—so the scene loses brilliance and snap. It will look "okay" as a small print but this softening means your photo will not be as good as it could be. No amount of Photoshopping will bring it back.

Just because a digital SLR is easy to hand-hold doesn't mean it will automatically produce its best results that way.

Proper technique, from cleaning your lens to holding or supporting your camera, has a huge effect on sharpness and helps get maximum precision from a lens.

After blowing or brushing off a lens, you can clean it gently with a folded, fresh microcloth. Breathe on the lens to help cleanse it, if needed.

The Best Ways to Clean Your Lens

1. Keep a blower in your bag. You can use compressed air, but a small blower is inexpensive, always works, and is more environmentally friendly. You can buy photo bulb-shaped blowers (one brand has a cool rocket shape) at the photo store, or you can look at the drug store for an ear syringe.

2. Blow debris off your lens regularly. This is a quick and easy thing to do and ensures you won't have little "sun specks," which come from light hitting the dust when shooting into the sun.

3. Use a lens cleaning microcloth. Available at camera stores, it is a special soft cloth that works very well for cleaning lenses. Use it to rub the lens gently (after first blowing the surface clean). By folding it over on itself, you can apply better pressure without pushing too hard. Breathe on the lens to help clean if needed. If the microcloth gets dirty, wash and dry it with your laundry.

4. Clean washed cotton can be used in a pinch. If you don't have a microcloth, try a well-washed soft cotton fabric. This could be a t-shirt, washcloth, or other piece of fabric. However, do your lens a favor and buy a lens-cleaning microcloth as soon as you can.

5. Soft brushes can help. A quality camel's hair brush is a good accessory for cleaning a lens.

Caution: It is vital to keep the brush clean and never touch the brush with your skin (that puts oil on it that can be transferred to your lens).

Antistatic brushes (available from camera stores) do an even better job—especially for static build-up, which will attract dust to your lens.

6. Serious cleaning needs a fluid. If your lens is really dirty, clean it in steps: Blow or brush off loose debris. Place a couple of drops of lens cleaning fluid (only the type specifically made for camera lenses) on a corner of your microcloth (never put it directly on your lens as it can get inside the lens and cause major problems). Wipe the moist cloth around the lens. Finally clean and buff with the dry part of the cloth.

7. These general cleaning steps apply to glass filters, too. Square or rectangle system filters are made of optical plastic and need special cleaners (available where you purchased those filters).

Unfortunately, the LCD screen can be very misleading with sharpness. Check to see if it gives the impression that the photo is sharper than it appears. To accurately judge sharpness, magnify the image (use the magnification feature of your camera).

Here's the best way to see how sharply your handholding technique captures an image: Compare the handheld shot to a photograph taken with the camera locked on a tripod.

Cameras get the maximum support for best stability when held with the left hand under the lens and the right hand on the right side of the camera, finger on the shutter.

In doing some informal tests with colleagues, and in workshops that I teach, I have found that most people using the handheld method start having trouble matching the steadiness of a tripod when the shutter speed drops below 1/125 second for standard lenses, and much faster for telephotos (even 1/500 second can be too slow for handholding a super-telephoto of 500mm or more). And don't forget that the focal length of a lens has more telephoto effect on a digital camera than the same lens has on a 35mm camera!

The solution when you are handholding? Use fast shutter speeds. Shutter speed can be a problem when photographers shoot totally automatically and assume the camera is taking care of the right speed. Major challenges occur with variable f/stop zoom lenses, since although the shutter speed might be okay for the wide-angle setting at f/3.5, it might not be when the lens is zoomed to telephoto because the lens loses speed (maybe going to f/5.6). Thus, a slower shutter speed has to be selected by the camera. This slower shutter speed may be the cause of unsharpness from handholding. Thus, you need to be especially wary of shooting in low light with the telephoto settings of variable aperture zooms.

Here's an old rule of thumb for sharpness that really works: Use a shutter speed for handholding that has the same number as the focal length of your lens or higher—never lower. For the 35mm

equivalent, this means that a 28mm lens needs at least a 1/30 second shutter speed, while a 200mm needs 1/200 second. You can see that a zoom such as an 80-200mm zoom might be able to be handheld at 1/125 second at 80mm. But, if you zoom in to 200mm, that requirement will jump to 1/250. If the lens is large and heavy you'll have to use faster speeds or, better yet, a tripod.

Proper Handholding Technique

Sharp pictures require good handholding technique and you should practice it at all times or image sharpness may be disappointing.

Hold the camera's grip in your right hand with your index finger on the shutter release. For horizontal or landscape-format pictures, cradle the lens and body in your left hand, so that your fingers can comfortably reach the lens' zoom and focusing rings. For vertical (or portrait-format) photos, turn the camera so your right hand is on top and the opposite end of the camera is cradled in your left hand. With either for-

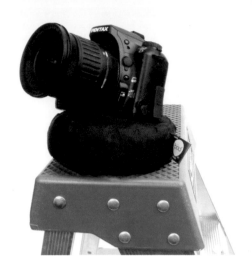

mat, keep your elbows in—pressed gently against your body—for additional support. Spread you legs in a firm, but comfortable, stance.

Practice in front of a mirror, until you feel comfortable holding the camera and tripping the shutter. Just after exhaling, press the shutter firmly with steady pressure.

Camera Supports

When light levels drop, or you are using long telephoto or macro lenses, use a camera support. You can get very handy little folding tripods for smaller SLRs that will fit a carrying bag (be sure the tripod feels stiff and stable—not bouncy). These can be set up anywhere on a table, a rock, against a wall, and so forth, and will help a lot. Bean pods are quite handy little devices that fit in most camera bags. They provide a soft medium that cushions and stabilizes the camera on a hard surface,

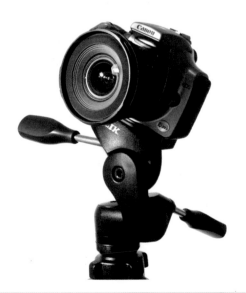

such as against a railing or fence post. Some bean pods even include a tripod screw so the camera or lens can actually be attached to the pod.

Tripods

There is no question that tripods will help you get the most out of your lens, but you need to invest in a good one. A cheap flimsy tripod can be worse than none at all. And don't look for a tripod with a long center column—they are extremely unsteady.

The key to buying a tripod is to be sure it is rigid and sturdy as a flexible, bouncy tripod will cause problems with camera movement. Set up a tripod to its full height (keep the center post down, though). Lean your weight on it and see how stiff it is. It should not flex much, bounce, or collapse.

Also, see how easily and securely the legs lock. The last thing you want to do is struggle with legs of a tripod when you are photographing—or have the tripod slowly lean to one side as one leg slips. Be sure the

Many photographers prefer the pan-and-tilt tripod head because the axes of movement can be separately adjusted and locked for precision fine-tuning.

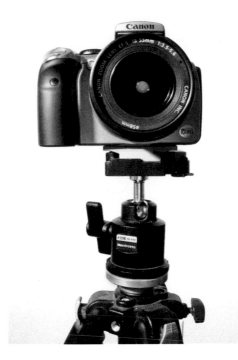

A ballhead offers infinite variation in adjustment with just one control, making it fast to set up when the tripod is on uneven ground.

prefer ballheads. Their disadvantage is that the camera can go in all directions at once. Thus, it can quickly tilt in an unexpected direction, which can be hazardous to the camera. This also makes it difficult to make very precise adjustments.

• Flash Made Easy

More and more pros have been using flash outside of the studio in recent years. Yet many amateurs—even very good photographers—used flash only sporadically with film cameras. Flash was hard to predict, especially when you were trying to balance flash and ambient (or existing) light. Even with the best automated systems you could never be totally sure you got what you wanted until you saw the photos. And too often the results just weren't satisfying.

I, too, used to be reluctant to use a lot of flash because I knew I would be throwing out a lot of film. Despite all the hype from

head is secure and easy for you to adjust. There are two common types of tripod heads for still photography: the pan-and-tilt head and the ballhead. The pan-and-tilt head uses multiple handles (or knobs) to lock the various axes of movement of the head. This allows you to adjust side-to-side angles separately from front-to-back. It allows very precisely controlled movement and the camera can never go off on its own direction. For this reason many studio photographers prefer it. The disadvantage is that this head takes more work to adjust and it tends to be bulky, with handles sticking out in sometimes awkward places.

The ballhead uses a single control to loosen tension on a ball-and-socket so the camera can be quickly positioned at any angle. It is much faster to set up a camera and much easier to adjust when the tripod is on uneven ground. These are some of the reasons nature photographers usually

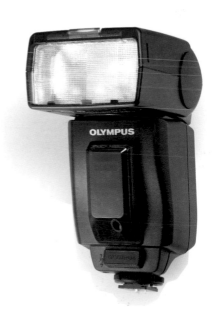

Digital cameras and automatic, dedicated flash are a terrific combination and make flash exposures easy and effective.

Every one of these portraits was shot with a single flash on a dedicated extension cord three feet long. The direction of the light is easily changed, plus it can be shot directly or bounced off of a wall or ceiling.

camera manufacturers about their flashes giving perfect exposures all the time, results could be very unpredictable. Now that the digital SLR has arrived, this has changed dramatically.

Flash units are built into some digital SLRs (quite handy) and you can add an accessory flash unit mounted on the hotshoe. Both manufacturers' and independents' (camera-brand specific) units work with all the bells-and-whistles you'd expect in a modern flash unit. (If you are not sure if a unit will work with your camera, check with your photo-graphic dealer.) Yes, flash exposure technol-ogy has not always been as good in digital cameras due to the way they measure flash exposure through the lens. Film cameras actually look at the light coming right off the film and digital cameras can't do that.

Frankly this really doesn't matter in practi-cal use. The digital SLR user has a secret weapon: Take a picture and check it! Film photographers (especially those in the stu-dio) would often shoot test Polaroids to check flash exposure and balance. You no longer have to do that. Your digital camera gives you the actual image on the LCD.

Balancing flash and ambient light was often a big challenge. Most of us don't have enough experience to automatically guess the right settings to balance these lights perfectly. Now, so what! Take that picture with the settings the camera gives you and check it immediately. Reviewing the image on the LCD will give you a good idea of what the flash is doing.

The Digital Flash Advantage

What is so great for the digital SLR photog-rapher is that you can use flash in all sorts of conditions without spending a lot of time trying to learn to control it. With the results immediately apparent, there's no need. You can see if you need to revise exposures so that you can get the perfect shot without

the hassles of film photography, which included a lot of guesswork and poor expo-sures on the lightbox. And when you got the film back, you couldn't change anything.

Buying a flash doesn't add a lot to your camera bag, yet it greatly increases your photographic possibilities.

Flash Tips

- Look for a full-powered unit that has the strength to balance even sunlight.

- Get a dedicated extension cord that you can connect to the flash because flash looks better when it is not com-ing directly from the camera position. You can aim the flash down from the sides and even from below for inter-esting effects.

- Flash units tend to be a little too cool in tone when used outdoors. Try taping a warming filter over the front of the flash. The plastic warming gels made for lights from Roscoe or Lee Filters work great for this. Try a 1/4 Straw or C.T. filter. Buy a sheet and cut to size.

Basic Flash Exposure

Digital SLRs use a flash exposure system that is very similar to the basic metering system. Both are through-the-lens sys-tems, so they only measure what the lens is seeing of your subject. Multi-segment metering systems (using distance calcula-tions) look at the light from the flash com-ing back from the subject and use sophisti-cated computer technology to select a good exposure for you. Most film cameras have similar capabilities. It is amazing that cameras today have more computer pro-cessing power than big business comput-ers typically had thirty years ago.

A significant change in autoflash metering from film to digital is that digital cameras do not typically measure the flash coming onto the sensor at the time of exposure (film cameras will measure the actual light hitting the film). So the camera will send off a burst of light called a preflash an instant before the flash exposure actually occurs. The preflash allows the camera to determine the exposure. This happens so fast that most people don't notice. For the actual exposure, the flash emits a specific duration of light and cuts itself off when the proper amount of light has been cast.

On most digital SLRs, you can control the flash exposure with flash exposure compensation. This works like regular compensation in that you can increase/decrease the exposure. It can't control the flash as much as regular exposure compensation however, because once you get past a certain distance to the subject, the flash doesn't have enough power to make the photo brighter. If you get too close, the flash may not be able to cut itself off fast enough to reduce exposure at a given f/stop.

One thing that will affect how you use the flash is its power. The power of a flash is given as a guide number, or GN. The number is usually given in feet and is based on an ISO of 100. This can be used as a rough guide for comparing the power of different flash units. It is not an exact guide, since there is no absolute standard for measuring guide numbers that is consistent among manufacturers. Guide numbers can only be used for comparison when they are based on the same thing (e.g., feet and 100 ISO). Guide numbers were once used to calculate exposure. The guide number was divided by the number of feet to the subject in order to get an f/stop (e.g., a GN 56 divided by 10 feet would give an f/stop of f/5.6 for the exposure).

Guide numbers not only can be used to calculate an f/stop, but when it comes to comparing them, they also act a little like f/stops themselves. Full f/stops are related to each guide number—they double or halve the light reaching the sensor as you step through them. A set of full f/stop numbers is 2, 2.8, 4, 5.6, 8, 11, and 16. If you take a group of flash units and put them in order from lowest to highest power, you might find they had GNs of 40, 56, 80, and 110. Each one of these is double the power of the previous unit and half the power of the next one.

Easy Flash Options

Most photographers use a flash aimed directly at the subject. This type of flash is useful when you need to see things in dark conditions. This is why paparazzi use this type of flash—they want to be sure their celebrity prey are not lost in weak light. You will also often need to use direct flash when your subject is some distance from you, as with sports or wildlife photography.

Unfortunately a lot of flash photos look like those deer-in-the-headlights paparazzi images. This type of lighting isn't flattering to the subject and can produce harsh, rather unattractive photographs. The light is flat, very susceptible to glare from shiny surfaces, causes dark shadows right behind subjects, and is the most likely suspect for red-eye. If it sounds like this type of light is not something I like, you are right. I try to avoid it whenever I can.

There are two easy ways to get better photos with a single flash unit and they don't require a lot of investment in money or time: off-camera and bounce flash. The digital SLR makes these techniques a joy to use because you can see the results and quickly adapt and adjust the light if you don't like the results.

Off-Camera Flash

Getting the flash off the camera immediately does a number of things: It makes

the light more dimensional with natural-looking shadows, places shadows better behind the subject, eliminates red-eye, and makes it less likely that shiny surfaces will bounce the light directly back at the camera.

The easiest way to take the flash off your camera is with a dedicated flash cord. This is a cord that attaches to the hotshoe of your SLR at one end and to the separated flash at the other. All of the dedicated flash automation is maintained, from exposure to the unit's zoom head, adjusting for the lens in use. The dedicated cord allows the camera and flash to communicate and coordinate timing electronically.

You could buy a big bracket for this off-camera flash (wedding photographers often use that for consistency and to keep the whole package in one piece) or even attach it to a stand. In each case you would aim the flash at the subject (or, in the case of the bracket, where the subject will be) for the best light direction. You will get a lot more versatility from your off-camera flash if you hold it. With a little practice you'll find it isn't that hard. This way you can hold it up high over the camera to the far left side (which is easier to reach), to the right side or even under the subject for special effects.

Since you are using a digital SLR, you will quickly see what the light from the flash looks like at that angle. Holding the flash high to the left is a comfortable way of creating a nice dimensional light with attractive shadows on the subject. Because the flash is high, any shadows that might fall on a wall behind the subject will now drop down below the subject in a much better position than shadows from a camera mounted flash. Since the camera is metering what it sees from the flash, exposures will generally be quite good (but of course you can vary them as needed).

You can also do some neat tricks hand-holding the flash to help your photo even more. By pointing the flash between the subject and background you can often get a more balanced light between subject and background (the background cannot be far behind, though, since light from a flash falls off quickly). If you can use a reflector on one side of the subject (and a white wall will work, too), you can point the flash so it just catches the subject but also heads to the reflector to add some nice fill light to the shadows.

How to Aim Your Flash

An old photojournalism trick is to hold the back of the flash head in your palm with your pointing finger riding on the top of flash. Then, when you point your finger at the subject, you'll be pointing the flash there as well.

The off-camera flash is really great for close-up work. You can put the flash in all sorts of positions related to the subject to get a whole range of lighting directions. When you are close, overexposure can be an issue but a really quick and easy way of dealing with this is to simply point the flash a little off the subject so that the most direct light does not hit it. By checking the LCD, you can get a perfect exposure very quickly.

If a flash head can be tilted upward, even while still attached to the camera, you can bounce the light off of the ceiling for a very natural look.

Bounce Flash

Bounce flash is another important flash technique. It can be used with any flash that tilts, or with off-camera flash. Here you point the flash at a white surface (ceiling, wall, FomeCor, reflector, etc.). This spreads the light out and softens its edges. It can be a very attractive and natural looking light for interiors and is especially effective when photographing people.

You change the direction of the light for very attractive dimensional lighting by aiming the flash at surfaces angled to the subject. A common and easy technique is to use the flash on the camera and bounce the light from the ceiling. Be careful you are not too close to a person or the light will come from almost directly above, creating nasty eye shadows. Some flash units have little white reflectors that pop up to correct this.

Multiple Flash

Photographers new to digital cameras might be puzzled by the reaction of a second flash, when it is triggered by a slave device (that triggers the remote unit when another flash goes off). If the second flash does not fire properly (because it was reacting to the first flash—the preflash), this can be corrected by special slave units.

Clearly this is not needed with manual exposure used for studio flash. Here the camera simply triggers the flash when the shutter is released.

Mixing Flash & Natural Light

Recent years have witnessed more and more photography in which a scene was subtly altered by flash mixed with the natural or ambient light. Ambient light is the light already existing before you arrived, so it is also called existing light. Pros use

the technique of enhancing an exposure with flash because it is a way to capture the natural look of a scene in its "native" light and still have some control over the contrasts within it. Modern auto flash metering systems communicate very well with the camera exposure system making this an easy and very effective technique.

The key to understanding this procedure is to realize that you are really creating a double exposure of two light sources—the natural light and the flash. Your camera creates an exposure for the existing light using both shutter speed and f/stop. The flash then creates a burst of light that matches the f/stop. The only requirement is that the shutter speed is at (or below) the camera's sync speed. You can shoot at as slow a shutter speed as needed to capture the natural light.

The only difference between these two images is the use of flash to brighten the foreground tree in the lower shot. Flash can fill crevices and shadows to bring out detail in dark areas.

Fill Flash

The most basic form of mixing flash and existing light is called "fill flash." This allows the flash to brighten shadows in very contrasty light. It is an ideal use for a built-in flash. Watch people taking pictures of each other on a bright, sunny day. Notice that contrasts create strong shadows on faces and under hat brims. Yet, although most of these people will have cameras with a built-in flash, the photographer rarely turns it on. A little bit of autoflash would help immensely.

Fill Flash Considerations

Most digital SLRs do very well with fill flash, although there are a few things to keep in mind:

- You will have an exposure for the brighter light along with a flash exposure for the shadows and the camera will calculate this for you.

- Check your LCD review because it will tell you if your camera did this well or not.

- If you are outdoors in the sun, you will not be able to use high ISO settings. Lower settings allow reasonable shutter speeds that match the flash sync speed.

If you get close to the subject you may find the flash overpowers the existing light. You might even want to tone down the flash (if you can) by adjusting the flash exposure compensation to –1 or more stops. This can make shadows appear more natural.

Unfortunately, every manufacturer makes different choices in how the metering system is set up for mixing flash and ambient light. On one camera, you may find it will not balance existing light in the P mode (because of the way shutter speed is set) but will in the Av (Aperture-Priority) mode. On another camera, all modes may work only if you hold a certain button during exposure. On yet another, all modes work fine without any change. Check your camera's manual.

Fill flash does not have to be restricted to daylight and brim shadows. It will help open up backlit subjects including shooting something against a sunset (the silhouette will now gain color and detail). It can be used to brighten colors on gloomy days. It

is a great technique to use to photograph a person at night and pick up details of the scene behind them. Some cameras have special exposure settings, called night flash or slow-sync, that are designed to automate the process of balancing the flash on a subject with a darker background.

Off-camera flash is another variation of the fill flash technique—you point the flash at parts of the scene that are in shadow and put light in very specific places. A good example of this would be a city scene that has nice light on the buildings across the street but only shadow on a street performer. By holding the flash off camera you get some nice modeling light and balance the subject to the brighter background. Landscape photographers use this technique to light up dark flowers when mountains in the background are lit by the sunset.

Slow Sync

Slow sync brings up another interesting technique—photographing motion with a flash. If you use a slow shutter speed to pick up the natural light on a moving subject, you will get both a blur and sharp photo at the same time. This can be a fun and striking use of flash. It creates a sense of energy with the subject. Check your LCD to see what shutter speed might work best for the movement.

If the movement is linear, however, you might not like the blur, as it will be in front of the subject. This is because the flash takes the picture at the first part of the exposure then the blur occurs afterward. To get the blur behind the subject, the flash has to go off at the end of the exposure. Digital SLRs with something called "rear-curtain" or "second-curtain" sync do exactly that, which gives a different effect than standard sync for movement shots.

High-Speed Sync

Some cameras offer something called high-speed sync that allows them to use much higher sync speeds than normal. This requires a special flash. To understand high-speed sync, you need to know how flash normally syncs with a digital SLR. The shutter on this type of camera is made up of two parts, called blades, that open and close over the sensor like curtains (and they are sometimes called shutter curtains). On some cameras they go vertically and on others horizontally.

One blade (or curtain) opens across the sensor allowing light from the lens to hit the sensor, and then the second blade follows behind at a distance that allows a specific shutter speed to be achieved. For high speeds, the second blade starts to close before the first is fully open so the full sensor is never acting all at once. Instead, what happens is more like a rectangular slit moving across the sensor.

At a certain speed the second blade starts to close, only after the first is fully open. So the full sensor area is exposed to the light at once. This is generally the highest sync speed on the camera because the flash must work when the sensor has its full

Ways to Use High-Speed Sync

- You can set a high shutter speed to underexpose even bright existing light conditions so that the flash exposure on your subject stands out more.

- Fill flash can be used at higher shutter speeds, which means you can use it to photograph a moving subject in existing light conditions and not have "ghosting" problems. Ghosting occurs when a slower sync speed isn't fast enough to stop the action in the existing light conditions. The flash does stop action, resulting in a sharp image surrounded by a blurred image when it isn't desired.

area exposed (or else it will only affect a sliver of the image). All slower shutter speeds will have fully opened curtains, so they will also work with flash.

High-speed flash does not work this way. It is designed to expose the sensor properly at speeds where both curtains are not open. The only way this can work is to have the flash pulse its light so that it is "on" at multiple points as the shutter opening moves across the sensor. This is very advanced technology and will give a good exposure.

picture-taking in the field

A good photographer I know recently purchased his first digital camera. He was excited to get started because he had heard you could do so much with the image in the computer. I suggested that he still might want to pay attention to details like shooting with filters.

"Filters?" he asked. "But this is a digital camera. Why would I need filters?"

Why filters indeed. As photographers go through this transition period where the recording medium changes from film to sensors and memory cards, there are many misconceptions about what digital photography can and cannot do. One common misunderstanding is that "digital" replaces traditional techniques and allows the photographer to magically get better photos—even "cheating" compared to working with film.

Inevitably, all photographers look for new purchases that offer "magic techniques" or that "silver bullet" that will improve their pictures. I have more than a couple of pieces of gear that sure seemed like they'd magically transform my photos when I bought them. What I ended up with was less space in my camera cabinet but no better photos. Digital cameras are not "magic equipment" and still have one important thing in common with film cameras—a bad photo is a bad photo, no matter what the recording medium. It takes a lot of work to make poorly shot pictures much better in the computer.

Photography is a craft requiring attention to detail if you want the best photos, regardless of the light-sensing technology. There is a limit to the detail that can be captured from bright to dark, for example. If the sensor captures no detail, no amount of work at the computer is going to bring it back.

Traditional techniques from filters to tripods are still vital to quality photography.

"Filters?" he asked. Yes, filters! Graduated or split neutral-density (ND) filter, for example, can be just as beneficial with a digital camera. This traditional tool allows you to control contrast from bright sky to dark land so that detail is captured in both areas. A polarizing filter is another great tool to have, as it will give you more saturated skies and enhanced colors in many landscape photographs. It is true that color-balancing filters are not used as often with digital cameras since the white balance settings of the camera correct for color temperature differences.

Tripods with good ballheads are a key ingredient for getting the sharpest images possible, and critical for the digital camera. Not too long ago, a friend of mine was complaining that his digital camera didn't seem to take photos that were as sharp as mine. I looked at his photos and saw evidence of camera movement. When I asked if he used a tripod, he was surprised:

"For this little camera? Why?"

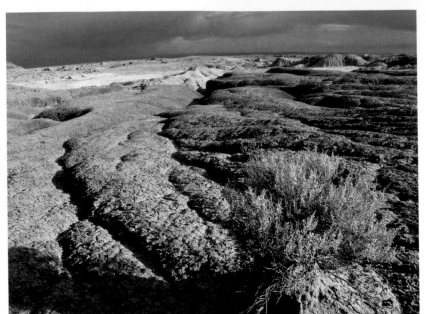

The details and techniques of traditional photography that result in top quality images still apply to digital. These two shots look similar, except the top photo was shot on a tripod, giving the image maximum sharpness and brilliance.

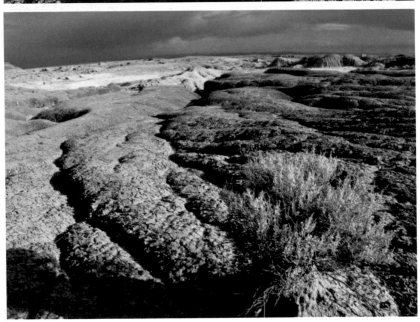

Using a tripod with a digital SLR reminds me of the days when I shot with a 4x5 view camera (this is the large camera with bellows in the center—lens on one end, ground glass viewing on the other, which is also where the film holder goes). The LCD screen is a lot like the 4x5 ground glass, except that the picture on the LCD is not upside down. With both you actually see a new rendering of the scene—you're not just looking at the subject through the viewfinder. And, both technologies require you to shield the viewing system from direct sun to see the colors vividly.

At dawn and dusk—prime times for landscape photography—that little LCD screen just glows with the image and really gives a good idea of what the photo will be like. Having the camera on a tripod guarantees

Digital photography is still photography when it comes to using the craft well. Shoot it correctly in the camera to achieve the highest image quality before you go to the computer.

that I will get the most from my camera's lens and megapixels, and the composition is easier to study on the monitor. A big advantage over film is that I can take the picture, study it on playback, erase it, and retake with different compositions, exposures, etc.

Exposure is another traditional film technique that is similar with digital cameras. Over- or under-exposure will cause detail and color to be lost. I remember shooting a scene in Arches National Park where I deliberately changed exposure slightly to see how I could affect the color of the early morning light. The exposure looked good on the LCD and on the histogram. The underexposed image looked dramatic and I thought, "Maybe it'll be okay."

I studied both images on the computer. No matter how much work I did on the under-exposed shot, I could never get its color to

equal that of the good exposure. Yet I could easily adjust the good exposure to achieve maximum drama.

As we use new technologies for recording photos, we still need to pay attention to traditional, time-tested film techniques. Photography is definitely a craft where experience counts. As long as the traditional techniques for capturing quality are followed—using a film or digital medium—a good photographer will remain a good photographer.

• Filters

Filters are absolutely essential to the photographer who wants to get the most from his or her photography. While warming filters and color correction filters are definitely less useful, the standard filters from polarizers to graduated neutral density

A graduated filter is a very important part of a photographer's tools. It helps balance contrast within a scene so that you can capture more detail.

Polarizing filters come in all sizes for any type of lens. They are consistently useful filters, offering controls not possible any other way.

filters are extremely helpful. Personally, I cannot imagine going out with my digital camera without a polarizer or graduated ND filter in my camera bag.

It is true that you definitely gain new control—adjusting exposure and contrast—using an image-processing program. However, what you capture in the first place has a huge influence on how much you can do to improve an image later. Filters can help a great deal to ensure you have the best possible image when you release the shutter, which will save time and work later at the computer. Remember, if you haven't captured detail in the first place you can't—except in a very artificial way—put it back in later. This has been true since the beginnings

of photography—even before the advent of digital!

There are three basic types of filters that most photographers should own: polarizing, graduated neutral density, and full neutral density filters. There are certainly other filters on the market that can be of use to the digital photographer but these are a good starter kit.

Hint: For more information on filters I recommend *Complete Guide to Filters for Digital Photography* by Joseph Meehan.

The polarizing filter has four important photographic effects:

1. **Darker skies**—When you shoot at 90 degrees to the sun, a polarizing filter will darken the blue in the sky—sometimes making it quite dramatic, "popping" the clouds out of the sky. You can rotate the filter to get a sky and clouds relationship that you like. There is no effect when you photograph directly toward or away from the sun. Depending on your position, the effect also changes gradually across the sky so, with wide-angle lenses, the sky will usually have a variation in tone. If this is annoying, you can try adding a graduated filter to darken the lighter area, or you can make some adjustments in the computer.

2. **Removing reflections**—A polarizing filter also removes reflections from glass, water, and other shiny surfaces, letting you see beneath them. It lets you see into things like a quiet pool in a stream. These filters will not, however, affect specular reflections when a bright light (such as the sun) reflects directly off the surface. When using a polarizer, be careful that you don't remove too much of the reflection needed to define the subject. Rotate the filter to get the effect you like. If you pho-tographed a window and removed all the reflection, it might look like there was no glass in it.

3. **Improved color saturation**—By removing surface reflections from subjects—like leaves—their color appears more saturated and less washed out.

4. **Haze reduction**—A polarizing filter can often reduce some haze in a distant scene. This doesn't always have a big impact, but it can be worth a try.

Polarizing Filters

This is one filter that every photographer should have. Some of its effects can be mimicked in the computer, but none can be exactly duplicated. This filter affects the way light goes through the lens and to the sensor, making the light waves "line up" instead of following a normal random pattern. The filter rotates in its mount, changing its orientation to the light waves, which changes its effect on the scene.

Exposure is generally pretty simple with modern TTL metering systems. The cam-era compensates for the darkness of the filter, which can act like a two-stop neu-tral density filter, and gives a correct exposure. You will notice the viewfinder will be getting darker as you adjust the filter. You may find that you prefer a brighter or darker exposure for certain scenes shot with this filter. Again, the LCD monitor will help.

A bigger issue is circular vs. linear polar-izers. This does not refer to the shape of the filter—it has to do with how the polarization is achieved. So what is the difference? With most modern cameras, a linear polarizer can create a situation where the light does not properly reach the AF or AE sensors, causing focus and/or exposure problems. The best bet is to just use a circular polarizer. This pre-vents any issues arising between filter and AF or AE systems.

Filters such as this graduated ND come in two types: screw–in (seen on page 150) and the square/rectangular system.

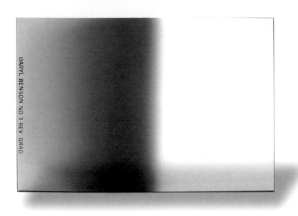

DARYL BENSON ND 3 REV GRAD

Graduated Neutral Density Filters

I consider these filters to be among the most useful for any photographer—especially photographers who like to photograph landscapes or travel scenes. Also called grads, graduated ND, and split ND filters, they are made half clear/half dark gray, with a blend (the gradation) or transition so there is no sharp line of difference. They rotate in their mount (the rectangular versions will also move up and down or side to side) so that the dark and clear parts of the filter will cover different areas in the photo.

The grad filter allows you to bring widely differing brightness in a scene more in line with what the camera sensor can handle. The easiest way to explain this is to look at a landscape scene with green trees and bright white clouds in the sky. No camera is going to easily capture that range of tones. By rotating the filter so that the dark part is over the white clouds, that area of the photo will be darkened. This results with the overall exposure of the photo becoming increased so that the trees are revealed without washing out the sky.

While the computer can help balance bright and dark areas in a photo, it would be difficult—in this example—to take a single exposure that would give enough detail in each area to allow the computer to show both trees and sky well. Sky is one of the prime candidates for the split ND filter since it is usually brighter than the ground. You can rotate the filter to compensate for hills and raise it up or down to deal with varied compositions.

You can use a grad for any situation where one part of the photo is much brighter than another. Outdoors, this might mean toning down a field of grass next to a stand of shadowy trees or balancing a bright band of light on the water with the rest of the photo. Indoors, this could be a way of bringing a window in line with the rest of the composition or to tone down a bright area of lights next to a stage. A grad can also be used creatively to darken a part of a photo, so a brighter area of the composition is emphasized. Maybe you are photographing a big scene inside your school and you want to be sure the kids at the bottom are noticed. Throw on a graduated ND filter and darken the top of the photo.

These filters also come in colors—mostly in warm tones and blues. This will allow you to both darken a part of the photo and color it as well. They are mostly used for skies—a blue grad will darken and color a weak blue sky, and a warm-color grad will intensify a sunrise or sunset.

In the top photo, a graduated ND filter balanced the exposure to allow the camera to capture the sunset light in the sky along with the rock. In the lower photo made with no filter, the sunset colors are gone and cannot be accurately brought back in the computer.

Exposure is not an absolute with these filters, and depends on what you want from the scene. For many situations just put the filter on and expose as you would normally. For tricky conditions, try bracketing your exposure (giving the scene extra shots with more and less exposure). Luckily you have a real advantage over the traditional film photographer with your digital SLR. You can now see what you are getting in your LCD, and even check the histogram to be sure.

Neutral Density Filters

These filters simply reduce the light coming through the lens without affecting color in any way (in essence, a dark gray filter). They come in different strengths from one-stop to about nine stops reduction in light.

The ND filter can be very useful. If you like extreme selective focus effects—shooting with the lens wide-open so that only the subject is sharp and everything else is out-of-

Neutral density, or ND, filters reduce the amount of light going into the camera, allowing you to use slower shutter speeds or deal with overly bright conditions.

focus—they can be a necessity. For example, if you used an f/2.8 lens, you would have to shoot at approximately 1/4000 second in bright sun in order to use f/2.8 at an ISO setting of 100 (faster if your camera starts at ISO 200). If your camera does not go that fast, the only answer is an ND filter.

A major use of an ND filter is to allow slow shutter speeds so you can capture blurs. With an 8x filter (which gives a two-stop change), you can get exposures of shaded streams or waterfalls of 1/2-1 second. Bright sun requires a stronger filter. The fragmented move-

ment captured by a faster shutter speed now blends to reveal flow patterns and water that appears smooth and milky. Many other subjects take on interesting looks when shot at slow shutter speeds. This offers great opportunities to experiment and push the envelope.

There are also extreme ND filters offering nine stops of change (equal to 1/500 the amount of light). You can't focus or compose through this filter (it's too dark), so you have to do that work before you mount the filter (so you will need a tripod). This filter allows you to do some really

Filters expand your options. This photo's colors came from the use of a polarizing filter that enriched the color of the leaves and darkened the blue sky.

unique photography. You can make exposures of many seconds—even in bright sun! This gives some fascinating blur and movement effects like the flow of a crowd. In the right light, you may even end up with exposures of 10, 20, or even 30 seconds, which will allow you to photograph a busy tourist location and make the tourists disappear! As long as no one stays in one spot very long the people will disappear from the scene.

• Image Control— Depth of Field

We explained the effect of lens choice on depth of field in the lens chapter. Here we'll expand on two other photographic variables that affect depth of field—f/stop and distance. You may remember that there are four things that affect depth of field (or the range of acceptable sharpness in a photograph from foreground to background): f/stop, distance, lens choice, and print size.

f/stop

As you reduce the size of the aperture in the lens (or go from a smaller f/number to a larger one), the amount of sharpness from front to back in a scene increases. So, for more depth of field, use a small lens opening; for less use a large lens opening. This is often confusing while shooting because of the way lens openings are expressed. On your camera you may get an exposure readout of 1/125 16, which means 1/125 second at f/16. The number 16 is not small, yet the f/stop it represents is. On the other hand f/2 is a large f/stop, though the number is smaller. So, high numbers represent small lens openings and low numbers represent larger ones. Confusing—right?

The f/stop of a lens is actually a fraction related to the size of the lens and the opening inside the lens that lets light through. So f/16 is actually a fraction—1/16—which now does seem small, and f/2 is really a much larger fraction (1/2). Still, if you always had to remember all that, it could drive you crazy. An easy way to relate depth of field to f/stop is to realize that depth of field increases as the f/stop number increases.

Sometimes you'll want a lot of depth of field for a landscape. Another time you may want minimal depth of field so that only your subject is sharp and the background out-of-focus. This is called selective focus. In this example, you would deliberately choose a very shallow depth of field by using a wide lens opening such as f/2.8.

Depth-of-Field Preview

Depth-of-field effects can be seen in the viewfinder by using the depth-of-field preview button on the camera. Since you normally focus and view through an SLR with the lens at its widest aperture (with the least depth of field), most digital SLRs offer this feature. When you shoot, the camera automatically stops the lens down to the picture-taking aperture, which affects the amount of depth of field. However, pushing in the preview button makes the camera stop the lens down to the taking aperture so you can see what its effect will be on depth of field.

When using this technique, you will see the viewfinder get dark (maybe very dark) if you have set something like f/16. This makes it hard to see the effects.

Use the Preview or the Review!
Look in the viewfinder—turn the preview on and off—and you can teach yourself to see the differences in depth of field at different apertures. If this proves too difficult, you can always take the picture and check

Depth of field is a key creative control for photographers, whether you want more (above) or less (below). The digital camera lets you immediately see the effects of changes in depth.

the LCD monitor afterward. This will show you depth of field, too, although you will have to magnify the image and move around in it in order to see everything.

Distance

How close you are to the subject strongly affects depth of field. As you move closer to a subject (or focus closer) the zone of sharpness begins to shrink. As you move away the zone expands. The zone of sharpness for depth of field is not equal on both sides of the focus point. It actually extends one-third in front and two-thirds behind.

There are a number of ways to apply this information on a practical basis. At a distance—whenever the lens is focused at faraway objects—the depth of field basically covers everything at that distance to infinity. The actual f/stop used has little impact on sharpness in depth. Since you

don't need a small f/stop, you could deliberately shoot at a higher shutter speed to minimize the effects of camera movement

At middle distances, aperture rules. Slight changes in f/stop can have significant effects on depth of field. This is where using the depth of field preview can really help.

At the opposite end, depth of field will be severely limited as you focus closer. When you get to macro distances, depth of field can be measured in fractions of an inch. Taking advantage of this, you can do some really neat selective focus effects. For more depth of field you are forced to use the smallest lens openings possible with your lens, which may mean you have to use flash in order to get enough light.

Distance between camera, subject, and background affects how sharply each of these elements will be rendered. This can be very important when you want a soft background that won't distract from your subject. When the subject is fairly close to the camera, it is easy to create an out-of-focus background. However, as the subject moves farther away from the camera, depth of field increases and it becomes more difficult to create a soft background. In this case, try stopping the lens down or using a longer focal length, which will decrease the depth of field and soften the background.

• Batteries

Early digital cameras were terrible power vampires and gave digital photography a very bad rap regarding batteries. They'd go through common alkaline batteries so fast that you'd need multiple sets for even a few hours of shooting. Since digital SLRs need more power and use it faster than a film camera, manufacturers have developed power-conserving technologies that have helped immensely. Still, batteries in a digital SLR do quit in a very short time compared to film cameras (where you might replace batteries once a year).

Battery drain is affected mainly by three things: how you use your camera battery, the types of batteries, and how the camera is engineered. We have no control over the engineering except to know that newer cameras will likely have better power usage. We can control how we use our cameras and, sometimes, the type of battery we use.

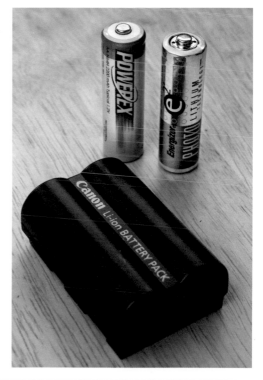

Digital cameras must have batteries to function. These are three common types that work well (left to right): lithium-ion, rechargeable NiMH and non-rechargeable lithium.

Conserving Batteries

If you know your battery resources are limited (whether because you are low on power, or you only have a few batteries that must last a specific time), here are some things you can do:

- **Minimize use of the LCD monitor—** I don't suggest that you never use it, which some people do in the name of power conservation. It is, after all, a big benefit to shooting digitally. However, it is also a big power user, so turn it off when you're not using it and set your instant review to a short time. (If battery reserves are low, turn it off altogether.)

- **Check auto-off settings—**Most digital SLRs can be set to different auto-off timings—pick one that best fit your needs. The camera auto-off is less critical than the monitor.

- **Don't overuse image stabilization features.**

- **If you use flash frequently—**Consider getting an accessory flash. The camera's built-in flash definitely uses up power quickly.

- **Turn camera off when not in use.**

Everyone uses cameras differently. This is why manufacturers pull their hair out trying to give a "battery life" rating. There is no such thing as a rating that will apply equally to all photographers. If you want to keep your battery life on the high side, pay attention to how you use certain power-hungry parts of your camera, which include the LCD monitor, built-in flash, autofocus, and even turning the camera on (making it go through a power-up sequence). A battery can actually start to show signs of low power (and the power bar shortens in the readout area) when multiple functions are happening at the same time—even though the camera may have enough power to shoot a while longer.

The last point is a very important one that not everyone knows about. It is possible to have a camera read "empty" on the battery scale but, after the camera is turned off for a while and the battery starts to recover, the reading rises. This is especially true after power-intensive use such as having the monitor on, the flash recharging, the lens autofocusing, and so forth—all in quick succession.

The right battery does make a difference in battery life, too. With many SLRs you do not have a choice. It is that battery or none. (Now there are independent manufacturers that do make replacement batteries for some cameras.) Typically, cameras with proprietary batteries are using rechargeable lithium-ion batteries. Manufacturers choose these because the lithium-ion battery has a high power output for its size, is very stable, and offers more than other types to the photographer.

Their disadvantage is inconvenience. If your proprietary battery dies, you are out of luck. You will not be able to walk into a local supermarket and buy a new one as you can with AAs. And for most of the lithium-ion batteries, there are no one-use back-ups available for you to keep in your bag for safety. (Some battery manufacturers are making one-use batteries for the very popular mini digital cameras—maybe they will for digital SLRs too.)

Three batteries (or sets) can insure that you always have battery power when you need it, especially when traveling.

Battery Types

For some cameras, AAs are obviously an important resource for the photographer. For the digital SLR, alkalines are really not of much use. They lose power quickly (although the special alkalines marketed for digital products do last longer and can be used in an emergency) and they cannot be recharged. Nickel-cadmium (NiCd) batteries can be recharged, but aren't usually recommended for digital camera use.

The two best AA battery types for photographers are rechargeable nickel-metal-hydride (NiMH) batteries and non-rechargable lithium batteries. NiMH batteries hold and release power well for digital cameras and can be recharged again and again. Their major disadvantage (true of all nickel-type batteries) is that they lose power just sitting. If you didn't use your camera for a month, you might discover your battery has a very short life—even though you just charged the batteries before you put the camera away. NiMH batteries will not give you their best right out of the package, either. They need to be charged and discharged a few times before they reach their full capacity. Sometimes photographers are disappointed in them after using them once, yet the batteries really aren't "conditioned" yet. Their capacity can even double after a few charging cycles.

Hint: Many SLRs will work with either type of battery. In an emergency you can fill in with non-rechargeable batteries. (Check your manual to be sure.)

Charging Batteries

How a battery is charged does affect its life. High-speed chargers are great when you are in rush but they will shorten the overall life of a battery. Sports photographers have discovered that they need to have back-up batteries if their rechargeables have been used hard for a while (both in the shooting and recharging) because they can just quit. Use standard chargers when you can to get the longest life from your batteries.

Back–Up Batteries

Lithium AAs are a great companion to NiMH and do hold their power just sitting—so you can buy a pack, throw it in your bag, and expect it to work years later. They are more expensive for a one-use battery (typically 2.5 times the price of standard alkalines) but they have 5-7 times the life (and actually offer much more life than even charged NiMH batteries). Lithium batteries are a great choice for back up and special conditions. They are lighter in weight than other AAs, work better in cold weather than most batteries, and will even last a long time under casual usage.

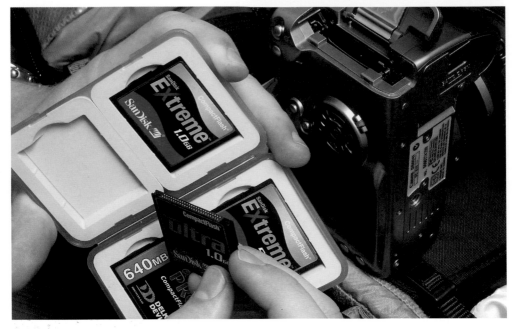

Digital is a great traveling companion. You can take hundreds of high quality images with a small package of memory cards, which are unaffected by security scanning machines.

Since batteries are essential to digital SLR operation, it is important to have multiple sets of batteries. Personally, I feel uncomfortable without at least three batteries per camera. They don't take up that much space and I don't ever want to be caught with a dead battery just as I am ready to shoot.

Digital: The Perfect Travel Companion

1. With high capacity memory cards, you can now carry the equivalent of whole bags of film in a pocket or your camera bag. But be careful; these small cards can be easily lost if kept as separate pieces tossed into a pocket or gadget bag.

2. A small memory card case is great for travel because it will keep your cards in one easily found location.

3. The LCD on your camera is a huge benefit for travel. It is like carrying photo insurance. It allows you to review your shots while still traveling, so you can be sure of your results. You'll never again be upset when looking at your processed film after the trip because you missed once-in-a-lifetime shots you thought you had. The LCD confirms your shot so you can move on or take another while the subject is still in front of you.

4. Send digital postcards during your trip. With today's Internet connections and Internet cafes everywhere, you can easily attach some photos to email so friends and relatives can see what you are seeing. Business travelers have also found this to be very useful, as they can send photos of products or procedures they are seeing back to the main office.

There are a number of benefits to taking a digital SLR when you are traveling, not the least is being able to see your vacation photos immediately.

• Traveling with a Digital Camera

Your digital SLR will give you some great new benefits for photographing when traveling. If you've traveled at all recently, you know how much security has changed at airports. Traditional film shooters really have a problem because film can be fogged by the big scanners used for checked bags. Yet carrying all their film for a trip through gate security can be a real pain. The digital SLR comes to the rescue. It is actually a lot easier to get through the airport with one of these cameras. The gate security systems have no effect on memory cards and you don't need to be burdened with lots of film. Fogged film is no longer a concern since you have no film.

An important concern when traveling with your digital SLR is protecting your photos. With memory cards available in gigabytes, you can carry the biggest memory cards you can afford and keep images on them until you get home. Consider that there are also other ways that you can give your images added protection and ensure you get them home.

Travel with a laptop? You could download your images to its hard drive. You can use a PC-card adapter if your computer has a PC-card slot. Otherwise you can usually use a USB card reader.

Hint: If your laptop has FireWire, go for that type of reader rather than USB, as it can be very fast.

I like to travel with a laptop that has a CD-burner, which allows me to make copies of

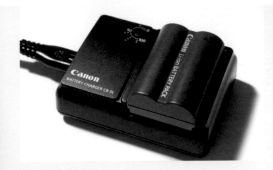

Don't Forget Your Charger!

In the last section we talked about batteries. They are a critical issue when traveling. You want to be sure you will always have power for your digital SLR. This includes the charger—without a charger your rechargeables are useless. Be certain you have the right adapters for your battery charger when going abroad.

all my images. This has become pretty much a standard way of working for pros. It can be funny to see a group of photo-journalists with black hoods over their heads as they download images to their laptops outdoors during the day (the hood makes the screen easier to see). CDs are pretty durable, so they travel well and you can make duplicates as you go for even more security.

There are a number of portable devices that allow you to download images to them as you travel. One type is built around a small and sturdy laptop hard drive. It has a slot for the card, battery power, and a monitor that either lets you see the device's menus or the photos themselves. Another type is the portable CD drive, which is becoming common in the market. It allows you to download images directly from a memory card to a CD.

As I mentioned in the battery section I like to have at least three sets of batter-

ies per camera body. You can probably shoot a whole day while traveling and maybe use up a single battery or battery set (when traveling we are rarely shooting constantly). Having a second battery all charged becomes my back up—although for this type of shooting I rarely use up the full charge of that battery in a day. Back at the hotel, the third battery is sitting on the charger.

When I return that night, I take the fully charged battery from the charger and put it in my camera. I then put the most dis-charged battery on the charger to charge overnight. The next morning I take that newly charged battery for backup in my camera bag and put the third partially used battery on the charger to start a whole new cycle that night.

Hint: If you have multiple camera bodies, consider getting battery chargers that can handle multiple batteries.

glossary

A

See aperture priority.

AA

Auto aperture. Refers to a Nikon flash mode in which the flash level is automatically adjusted for aperture.

aberration

An optical flaw in a lens that causes the image to be distorted or unclear.

Adobe Photoshop Elements

An image-processing program designed for the avid photographer. The Elements program does not have all the highest-end controls employed by professional photographers and graphic artists using Photoshop. It does, however, include powerful options such as cropping, exposure and contrast controls, color correction, layers, adjustment layers, panoramic stitching, and others.

AE

See automatic exposure.

AF

See automatic focus.

AI

Automatic Indexing.

ambient light

See available light.

angle of view

The area seen by a lens, usually measured in degrees across the diagonal of the film frame.

aperture

The opening in the lens that allows light to enter the camera. Aperture is usually described as an f/number. The higher the f/number, the smaller the aperture; and the lower the f/number, the larger the aperture.

aperture priority

A type of automatic exposure in which you manually select the aperture and the camera automatically selects the shutter speed.

artifact

Information that is not part of the scene but appears in the image due to technology. Artifacts can occur in film or digital images and include increased grain, flare, static marks, color flaws, noise, etc.

artificial light

Usually refers to any light source that doesn't exist in nature, such as incandescent, fluorescent, and other manufactured lighting.

astigmatism

An optical defect that occurs when an off-axis point is brought to focus as sagittal and tangential lines rather than a point.

automatic exposure

When the camera measures light and makes the adjustments necessary to create proper image density on sensitized media.

automatic flash

An electronic flash unit that reads light reflected off a subject (from either a preflash or the actual flash exposure), then shuts itself off as soon as ample light has reached the sensitized medium.

automatic focus

When the camera automatically adjusts the lens elements to sharply render the subject.

Av

Aperture Value. See aperture priority.

available light

The amount of illumination at a given location that applies to natural and artificial light sources but not those supplied specifically for photography. It is also called existing light or ambient light.

backlight

Light that projects toward the camera from behind the subject.

backup

A copy of a file or program made to ensure that, if the original is lost or damaged, the necessary information is still intact.

barrel distortion

A defect in the lens that makes straight lines curve outward away from the middle of the image.

bit

Binary digit. This is the basic unit of binary computation. See also, byte.

bit depth

The number of bits per pixel that determines the number of colors the image can display. Eight bits per pixel is the minimum requirement for a photo-quality color image.

bounce light

Light that reflects off of another surface before illuminating the subject.

brightness

A subjective measure of illumination. See also, luminance.

buffer

Temporarily stores data so that other programs, on the camera or the computer, can continue to run while data is in transition.

built-in flash

A flash that is permanently attached to the camera body. It will pop up and fire in low-light situations when using the camera's automated exposure settings.

built-in meter

A light measuring device that is incorporated into the camera body

bulb

A camera setting that allows the shutter to stay open as long as the shutter release is depressed.

byte

Eight bits. See also, bit.

card reader

Device that connects to your computer and enables quick and easy download of images from memory card.

CCD

Charge Coupled Device, a common sensor type for digital cameras from which pixels are interpreted sequentially by the circuitry that surrounds the sensor.

chromatic aberration

Occurs when light rays of different colors are focused on different planes, causing colored halos around objects in the image.

chrominance

Hue and saturation information.

chrominance noise

A form of artifact that appears as a random scattering of densely packed colored "grain." See also, luminance and noise.

close-up

A general term used to describe an image created by closely focusing on a subject. Often involves the use of special lenses or extension tubes. Also, an automated exposure setting that automatically selects a large aperture (not available with all cameras).

CMOS

Complementary Metal Oxide Semiconductor a sensor type used in digital cameras as a recording medium that converts light into digital images. CMOS sensors are similar to CCDs but allow individual processing of pixels, are less expensive to produce, and use less power.

color balance

The average overall color in a reproduced image. How a digital camera interprets the color of light in a scene so that white or neutral gray appear neutral.

color cast

A colored hue over the image often caused by improper lighting or incorrect white balance settings. Can be produced intentionally for creative effect.

color space

A mapped relationship between colors and computer data about the colors.

CompactFlash (CF) card

One of the most widely used removable memory cards.

complementary colors

In theory: any two colors of light that, when combined, emit all known light wavelengths, resulting in white light. Also, it can be any pair of dye colors that absorb all known light wavelengths, resulting in black.

compression

Method of reducing file size through removal of redundant data, as with the JPEG file format.

contrast

The difference between two or more tones in terms of luminance, density, or darkness.

contrast filter

A colored filter that lightens or darkens the monotone representation of a colored area or object in a black-and-white photograph.

CPU

Central Processing Unit. This is the "brains" of a computer or a lens.

critical focus

The most sharply focused point of an image.

cropping

The process of extracting a portion of the image area. If this portion of the image is enlarged, resolution is subsequently lowered.

daylight
A white balance setting that renders accurate color when shooting in mid-day sunlight.

dedicated flash
An electronic flash unit that talks with the camera, communicating things such as flash illumination, lens focal length, subject distance, and some-times flash status.

default
Refers to various factory-set attrib-utes or features, in this case of a camera, that can be changed by the user but can, as desired, be reset to the original factory settings.

depth of field
The image space in front of and behind the plane of focus that appears acceptably sharp in the pho-tograph.

diaphragm
A mechanism that determines the size of the lens opening that allows light to pass into the camera when taking a photo.

digital zoom
The cropping of the image at the sen-sor to create the effect of a telephoto zoom lens. The camera interpolates the image to the original resolution. However, the result is not as sharp as an image created with an optical zoom lens because the cropping of the image reduced the available sen-sor resolution.

diopter
A measurement of the refractive power of a lens. Also, it may be a supplementary lens that is defined by its focal length and power of magnifi-cation.

download
The transfer of data from one device to another, such as from camera to computer or computer to printer.

dpi
Dots per inch, referring to printing resolution.

dye sublimation printer
Creates color on the printed page by vaporizing inks that then solidify on the page.

EI
See exposure index.

electronic flash
A device with a glass or plastic tube filled with gas that, when electrified, creates an intense flash of light. Also called a strobe. Unlike a flash bulb, it is reusable.

EV
See exposure value.

EXIF
Exchangeable Image File Format. This format is used for storing an image file's interchange information.

exposure
When light enters the camera and reacts with the sensitized medium. The term can also refer to the amount of light that strikes the light sensitive medium.

exposure meter
See light meter.

extension tube
A hollow metal ring that can be fitted between the camera and lens. It increases the distance between the optical center of the lens and the sen-sor and decreases the minimum focus distance of the lens.

f/

See f/stop

file format

The form in which digital images are stored and recorded, e.g., JPEG, RAW, TIFF, etc.

filter

Usually a piece of plastic or glass used to control how certain wavelengths of light are recorded. A filter absorbs selected wavelengths, preventing them from reaching the light sensitive medium. Also, software available in image-processing computer programs can produce special filter effects.

FireWire

A high speed data transfer standard that allows outlying accessories to be plugged and unplugged from the computer while it is turned on. Some digital cameras and card readers use FireWire to connect to the computer. FireWire transfers data faster than USB.

flare

Unwanted light streaks or rings that appear in the viewfinder, on the recorded image, or both. It is caused by extraneous light entering the camera during shooting. Diffuse flare is uniformly reflected light that can lower the contrast of the image. Zoom lenses are susceptible to flare because they are comprised of many elements. Filters can also increase flare. Use of a lens hood can often reduce this undesirable effect.

f/number

See f/stop.

focal length

When the lens is focused on infinity, it is the distance from the optical center of the lens to the focal plane.

focal plane

The plane on which a lens forms a sharp image. Also, it may be the film plane or sensor plane.

focus

An optimum sharpness or image clarity that occurs when a lens creates a sharp image by converging light rays to specific points at the focal plane. The word also refers to the act of adjusting the lens to achieve optimal image sharpness.

FP high-speed sync

Focal Plane high-speed sync. This is offered by some flash units that emit rapid flash pulses so that the unit will synchronize at camera shutter speeds higher than the standard sync speed.

frame

The complete image-exposure area.

f/stop

The size of the aperture or diaphragm opening of a lens, also referred to as f/number or stop. The term stands for the ratio of the focal length (f) of the lens to the width of its aperture opening. (f/1.4 = wide opening and f/22 = narrow opening.) Each stop up (lower f/number) doubles the amount of light reaching the sensitized medium. Each stop down (higher f/number) halves the amount of light reaching the sensitized medium.

full-sized sensor

A sensor with the same dimensions as a 35mm film frame.

GB

See gigabyte.

gigabyte

Just over one billion bytes.

GN

See guide number.

gray card

A card used to take accurate exposure readings. It typically has a white side that reflects 90% of the light and a gray side that reflects 18%.

Gray scale

A successive series of tones ranging between black and white, which have no color.

guide number

A number used to quantify the output of a flash unit. It is derived by using this formula: GN = aperture x distance. Guide numbers are expressed for a given ISO film speed in either feet or meters.

hard drive

A contained storage unit made up of magnetically sensitive disks.

histogram

A graphic representation of image tones.

hot shoe

An electronically connected flash mount on the camera body. It enables direct connection between the camera and an external flash, and synchronizes the shutter release with the firing of the flash.

icon

A symbol used to represent a file, function, or program.

image-processing program

Software that allows for image alteration and enhancement.

infinity

A term used to denote the theoretically most distant point of focus.

interpolation

Process used to increase image resolution by creating new pixels based on existing pixels. The software intelligently looks at existing pixels and creates new pixels to fill the gaps and achieve a higher resolution.

IS

Image Stabilization, a technology that reduces camera shake and vibration. It is used in lenses, binoculars, camcorders, etc.

ISO

From ISOS (Greek for equal), a term for industry standards from the International Organization for Standardization. When an ISO number is applied to film, it indicates the relative light sensitivity of the recording medium. Digital sensors use film ISO equivalents, which are based on enhancing the data stream or boosting the signal.

JFET

Junction Field Effect Transistor, which are used in digital cameras to reduce the total number of transistors and minimize noise.

JPEG

Joint Photographic Experts Group. This is a lossy compression file format that works with any computer and photo software. JPEG examines an image for redundant information and then removes it. It is a variable compression format because the amount of leftover data depends on the detail in the photo and the amount of compression. At low compression/high quality, the loss of data has a negligible effect on the photo. However, JPEG should not be used as a working format—the file should be reopened and saved in a format such as TIFF, which does not compress the image.

KB

See kilobyte.

kilobyte

Just over one thousand bytes.

latitude

The acceptable range of exposure (from under to over) determined by observed loss of image quality.

LBCAST

Lateral Buried Charge Accumulator and Sensing Transistor array. This is an array that converts received light into a digital signal, attaching an amplification circuit to each pixel of the imaging sensor.

LCD

Liquid Crystal Display, which is a flat screen with two clear polarizing sheets on either side of a liquid crystal solution. When activated by an electric current, the LCD causes the crystals to either pass through or block light in order to create a colored image display.

LED

Light Emitting Diode. It is a signal often employed as an indicator on cameras as well as on other electronic equipment.

lens

A piece of optical glass on the front of a camera that has been precisely calibrated to allow focus.

lens hood

Also called a lens shade. This is a short tube that can be attached to the front of a lens to reduce flare. It keeps undesirable light from reaching the front of the lens and also protects the front of the lens.

lens shade

See lens hood.

light meter

Also called an exposure meter, it is a device that measures light levels and calculates the correct aperture and shutter speed.

long lens

See telephoto lens.

lossless

Image compression in which no data is lost.

lossy

Image compression in which data is lost and, thereby, image quality is lessened. This means that the greater the compression, the lesser the image quality.

luminance

A term used to describe directional brightness. It can also be used as luminance noise, which is a form of noise that appears as a sprinkling of black "grain." See also, brightness, chrominance, and noise.

macro lens

A lens designed to be at top sharpness over a flat field when focused at close distances and reproduction ratios up to 1:1.

main light

The primary or dominant light source. It influences texture, volume, and shadows.

manual exposure

A camera operating mode that requires the user to determine and set both the aperture and shutter speed. This is the opposite of automatic exposure.

MB

See megabyte.

megabyte
 Just over one million bytes.

megapixel
 A million pixels.

memory
 The storage capacity of a hard drive or other recording media.

memory card
 Typical recording medium of digital cameras. Memory cards can be used to store still images, moving images, or sound, as well as related file data. There are several different types, e.g., CompactFlash, SmartMedia, xD, Memory Stick, etc. Individual card capacity is limited by available storage capacity as well as by the size of the recorded data, such as image resolution.

menu
 An on-screen listing of user options.

middle gray
 Halfway between black and white, it is an average gray tone with 18% reflectance. See also, gray card.

midtone
 The tone that appears as medium brightness, or medium gray tone, in a photographic print.

mode
 Specified operating conditions of the camera or software program.

MOSFET
 Metal Oxide Semiconductor Field Effect Transistor, which is used as an amplifier in digital cameras.

noise
 The digital equivalent of grain. It is often caused by a number of different factors, such as a high ISO setting, heat, sensor design, etc. Though usu-

ally undesirable, it may be added for creative effect using an image-processing program. See also, chrominance noise and luminance.

normal lens
 See standard lens.

overexposed
 When too much light is recorded with the image, causing the photo to be too light in tone.

pan
 Moving the camera to follow a moving subject. When a slow shutter speed is used, this creates an image in which the subject appears sharp and the background is blurred.

Perspective
 The effect of the distance between the camera and image elements upon the perceived size of objects in an image. It is also an expression of this three-dimensional relationship in two dimensions.

pincushion distortion
 A flaw in a lens that causes straight lines to bend inward toward the middle of an image.

pixel
 Derived from picture element. A pixel is the base component of a digital image. Every individual pixel can have a distinct color and tone.

plug-in
 Third-party software created to augment an existing software program.

polarization
 An effect achieved by using a polarizing filter. It minimizes reflections from non-metallic surfaces like water and glass and saturates colors by removing glare. Polarization often makes skies appear bluer at 90 degrees to

the sun. The term also applies to the above effects simulated by a polarizing software filter.

RAM

Stands for Random Access Memory, which is a computer's memory capacity, directly accessible from the central processing unit.

RAW

An image file format that has little or no internal processing applied by the camera. It contains 12-bit color information, a wider range of data than 8-bit formats such as JPEG.

RAW+JPEG

An image file format that records two files per capture; one RAW file and one JPEG file.

resolution

The amount of data available for an image as applied to image size. It is expressed in pixels or megapixels, or sometimes as lines per inch on a monitor or dots per inch on a printed image.

S

See shutter priority.

saturation

The intensity or richness of a hue or color.

sharp

A term used to describe the quality of an image as clear, crisp, and perfectly focused, as opposed to fuzzy, obscure, or unfocused.

short lens

A lens with a short focal length—a wide-angle lens. It produces a greater angle of view than you would see with your eyes.

shutter

The apparatus that controls the amount of time during which light is allowed to reach the sensitized medium.

shutter priority

An automatic exposure mode in which you manually select the shutter speed and the camera automatically selects the aperture.

single-lens reflex (SLR)

A camera with a mirror that reflects the image entering the lens through a pentaprism or pentamirror onto the viewfinder screen. When you take the picture, the mirror reflexes out of the way, the focal plane shutter opens, and the image is recorded.

small-format sensor

In a digital camera, this sensor is physically smaller than a 35mm frame of film. The result is that standard 35mm focal lengths act like longer lenses because the sensor sees an angle of view smaller than that of the lens.

standard lens

Also known as a normal lens, this is a fixed-focal-length lens usually in the range of 45 to 55mm for 35mm format (or the equivalent range for small-format sensors). In contrast to wide-angle or telephoto lenses, a standard lens views a realistically proportionate perspective of a scene.

stop

See f/stop.

stop down

To reduce the size of the diaphragm opening by using a higher f/number.

stop up

To increase the size of the diaphragm opening by using a lower f/number.

strobe
Abbreviation for stroboscopic. An electronic light source that produces a series of evenly spaced bursts of light.

synchronize
Causing a flash unit to fire simultaneously with the complete opening of the camera's shutter.

telephoto effect
When objects in an image appear closer than they really are through the use of a telephoto lens.

telephoto lens
A lens with a long focal length that enlarges the subject and produces a narrower angle of view than you would see with your eyes.

thumbnail
A miniaturized representation of an image file.

TIFF
Tagged Image File Format. This popular digital format uses lossless compression.

tripod
A three-legged stand that stabilizes the camera and eliminates camera shake caused by body movement or vibration. Tripods are usually adjustable for height and angle.

TTL
Through-the-Lens, i.e. TTL metering.

Tv
Time Value. See shutter priority.

USB
Universal Serial Bus. This interface standard allows outlying accessories to be plugged and unplugged from the computer while it is turned on. USB 2.0 enables high-speed data transfer.

viewfinder screen
The ground glass surface on which you view your image.

vignetting
A reduction in light at the edge of an image due to use of a filter or an inappropriate lens hood for the particular lens.

VR
Vibration Reduction, a technology used in such photographic accessories as a VR lens.

wide-angle lens
A lens that produces a greater angle of view than you would see with your eyes, often causing the image to appear stretched. See also, short lens.

Wi-Fi
Wireless Fidelity, a technology that allows for wireless networking between one Wi-Fi compatible product and another.

zoom lens
A lens that can be adjusted to cover a wide range of focal lengths.

index